FITTER
HAPPIER
HEALTHIER

The Ultimate Body Plan

Kate Ferdinand

MICHAEL JOSEPH

an imprint of

PENGUIN BOOKS

FOR: Rio, Lorenz, Tate and Tia —
you are my absolute world. Thank
you for coming into my life at just the
right time and changing it for the
better. I cannot imagine life without
you all x

Contents

Introduction

I really want to help you get the kind of body you feel great about every day.

In this book I'm going to show you how I balance living my life and having fun with staying in shape. No gimmicks, no fads and no misery eating. You're going to eat lovely food, you're going to move your body and you're going to practise self-care, because that's what you deserve.

Let me start off by saying that I'm a really normal person. I don't spend endless hours in the gym every day, I don't live on green smoothies (that would make me cry), and I'm not that person who waves off the bread basket whenever I go out for dinner. I eat well and I work out regularly, but I also enjoy meals out and eating chips (just not every day).

I do what works for me while enjoying my life. Even when I was getting married I didn't go crazy and stop eating all the things I love. I was never going to be that person who starved themselves and got super-skinny for their wedding day. In the run-up I carried on eating and exercising the way I always have because that's what suits me and my body.

Everywhere we look we're told what to eat, what not to eat, how we should exercise, and how we shouldn't. It's so confusing. In the past I've tried everything. I've been on juice cleanses and soup diets. Sometimes those things would work temporarily, but more often than not I'd last a couple of days on a new regime, feel cross and hungry, and end up bingeing on rubbish. Or I'd go on holiday, break the routine and put any weight I'd lost back on again – and then some. The problem is, I like eating food, and my body likes being fed the nutrients it needs, so the quick fixes never truly work. They never, ever fix anything; they just make me annoyed and frustrated.

I've worked out since my early teens and that's always been a constant in my life. Through trial and error I've learnt what I enjoy, what I don't, and what works for me. In that sense I feel like I've had exercise figured out for a long time. My eating habits, however, were another matter.

Having tried every diet going, several years ago I realized that something wasn't working for me. So I went back to basics and began eating a balanced diet and listening to my body. It sounds simple, but it works. No crazy shakes, no getting up at 4 a.m. to do twenty-mile runs and no denying myself the things I love or skipping meals as that isn't the answer. And do you know what? I've never been happier with my body, or felt healthier.

I think when we jump on and off diets, or we're 'feast or famine', our bodies get confused, go into panic mode and they stop working as well as they should. Nowadays I would never deprive my body of what it needs, which is healthy, nutritious food.

We're all after a quick fix, and I understand why, because I've been there, but it's not sustainable. Slow, steady weight loss is the right approach, because then the weight stays off. I also think that's how your body learns to trust you again after years of deprivation.

You are going to lose weight almost straight away with this kick-start plan, but you're also going to learn lifelong habits. And if you have them, you'll lose any fears you have around food because you'll see how well your body works when you put the right things in.

'I went back to basics and began eating a balanced diet and listening to my body. It sounds simple, but it works.'

This book isn't a diet; it's a lifestyle plan, and by that I mean you can, without a doubt, follow it for ever, because it's sensible and it's achievable and it will work long-term. I'm not expecting you to live on lettuce (which I hate, by the way), and I don't want you to be terrified at the sight of a packet of crisps. I just want you to take care of yourself by moving your body and putting good things into it.

My approach is simple. I exercise and eat well most of the time so I'm able to enjoy myself and drink a few cocktails when I go on a night out. I would hate to be one of those people who are too scared of living life to the full in case they put on weight. I don't want my world to be really small because I'm worried I may fluctuate by a pound or two here and there. That's just not me. Imagine if being skinny was your sole focus in life but you weren't having a good time because you couldn't ever let yourself go? Being slim is great, but so is seeing friends and family and having fun. This book is all about showing how you can look amazing and live your best life at the same time.

I'm a normal woman and my weight does fluctuate. I know that feeling of panic when your jeans don't fit like they did the previous week, but that shouldn't lead to panic dieting. You'll only end up in a negative loop of starving and bingeing. I've learnt not to panic because I know that once I'm back on track with my eating and exercise my body will balance out again. I am proof that if you keep a good routine going and eat sensibly your body will stay on track. It's so much cleverer than you realize.

The plan is designed to help you get in shape and learn healthy new habits, and hopefully the things you will take away from it will last a lifetime. I'm not claiming to be an all-round expert who has qualifications coming out of their ears; I'm just showing you what works for me, and has done for years. I've learnt how to stay at a healthy weight through trial and error, and now I want to pass that wisdom on to you.

Let's get started!

Kate x

Chapter 1
MIND

A bit about me

'YOU'VE ALWAYS HAD THE POWER, MY DEAR; YOU JUST HAD TO LEARN IT FOR YOURSELF.' **The Wizard of Oz**

Before we get on to the health and fitness sections I'm going to fill you in on my diet and fitness background, so feel free to skip forward if you want to crack on right this minute!

I was brought up in Essex by my mum. My mum and dad split up when I was three and I'm an only child, so it was just me and my mum living together in a small house in Hornchurch.

I was quite a naughty kid and a real chatterbox, so I often used to get into trouble at school. I was a bit cheeky but I still worked hard and did well in my exams.

I've always been active and from Year Eight my mum and I used to go swimming three days a week before school. Later the same year we started going to the gym together, and aside from doing sport at school that was the first time I properly exercised. Some days we'd swim and go to the gym, so from the age of twelve or thirteen I was working out pretty regularly and I loved the way it made me feel. I was only young then so it wasn't anything to do with me toning up or losing weight; it just felt really good for me mentally. I knew that I always felt better when I came out of the gym than I did before I went in.

Looking back, I suffered from pretty bad anxiety. But, of course, back then I didn't know what it was. All I knew was that sometimes I didn't feel that great and things bothered me a lot. The smallest thing could happen and it would play on my mind,

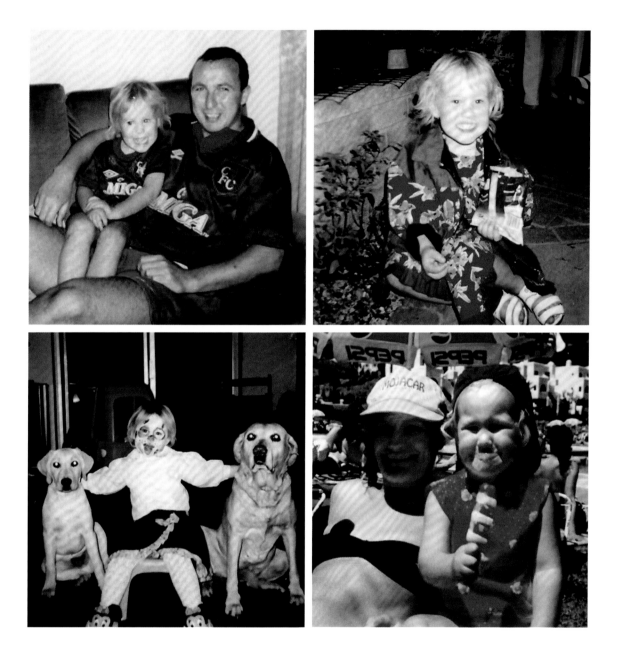

and the same thoughts would go round and round my head. I didn't know how to stop them, but exercise seemed to help. If I had those horrible feelings, when I exercised they went away. As I've got older I've realized what it is, what causes it and how I can help it.

I was a bit of a chubby child, but I didn't think about it and it didn't bother me in the slightest. Then in my early teens my boobs started growing, my hips started getting wider and my waist got smaller. That's when I started to become really aware of my body for the first time. I began to get curves, but all my friends were small and skinny so I felt bigger next to them, which isn't great at that age.

I think because I was one of the first in my year to develop I was very self-conscious as I went into my teens. My friends and I would all get ready to go out and just before we were due to leave the house I'd look in the mirror, panic and say, 'I'm really sorry, I'm not coming out.' I felt very self-conscious. I'd stay in and cry instead. I think it was partly down to my anxiety, and partly down to feeling like I looked very different. It was pretty crippling at times.

Even now I'm bigger up top and down below, but I've got a small waist, so my figure started showing early. Back then I looked like a smaller version of how I am now, but still very curvy. I definitely didn't look like a thirteen-year-old at all; I honestly looked nearer seventeen, which I think probably gave my mum heart palpitations.

These days I don't feel different because of my body. A lot of women have surgery so having bigger boobs is the norm, but back then it wasn't. My mates were desperate for their boobs to grow and mine seemed to be getting bigger by the day. I went to an all-girls' school where I had my little group of friends and we were all really supportive of each other. I was always quite grown up for my age and I focused on other things, so gossiping about other people wasn't something that interested me.

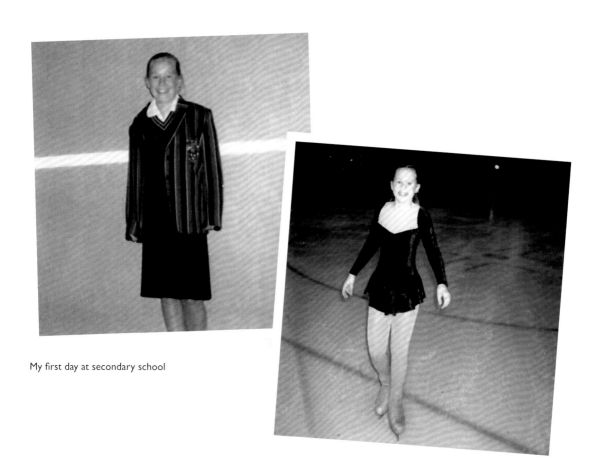

My first day at secondary school

/ *'I was always quite grown up for my age and I focused on other things, so gossiping about other people wasn't something that interested me.'*

The other thing that blighted my teens was my skin. I suffered from acne and as a result I got put on the pill when I was fourteen to try to clear it up. I don't think the hormones reacted well with me, and I became a very moody teenager. I now know that the pill I was on is renowned for causing mood swings, and it turned me into a bit of an angry kid. I became a completely different person and I was a loose cannon for a while. I had a very short fuse, and my mum still says I was a nightmare. At the time I didn't realize my up-and-down moods were due to the medication, but now it makes sense. As a teenager your hormones are already all over the place, and when you add synthetic ones into the mix it's potentially a recipe for disaster.

My mum and my lovely nan

I hated having bad skin because you can't hide your face away. If you feel self-conscious about your body you can hide it under clothes to a certain extent, but you have to literally face the world every day, and your skin is one of the first things people notice.

I wore make-up from a young age, and if I had a really bad breakout it would be another reason for me not to go out. It was hard enough having to go to school every day with acne, let alone anywhere else. There were times when people actually said to me, 'What's wrong with your skin?' When you hear something like that it makes you want to run and hide.

Sometimes I used to point out how bad my skin was to people so I could mention it before they judged me on it. I still do that now. If I'm a bit bloated or my hair isn't looking great, I'll tell people so they don't get a chance to think it. I know a lot of my mates do the same and we often laugh about it. Why do we do that to ourselves?

My weight went up and down in my teens, probably because of hormones and things, and I wasn't great with that. I didn't feel as happy with myself if I put on weight, and that's why I developed a routine with exercise early on.

Growing up, my mum always made me proper home-cooked food, like lasagne or shepherd's pie, which I loved. Then in my mid-teens I became more aware of what I was putting in my mouth so I would ask for sweet potatoes instead of regular potatoes, and make little tweaks here and there so I could be healthier. My poor mum! She'd be really good and buy all the food I needed for my new regime, and then I'd change things up again because I'd hear about some new magic health kick. I have to say she was very patient with me.

I used to make my mum hide all the chocolate and sweets from me, and then when it was my time of the month I would scour the house looking for them. Honestly, I'd be like a madwoman. My mum would come back and find me surrounded by empty sweet wrappers and she'd be like, 'What's wrong with you? You ask me to hide things and then you find them and eat them all anyway!'

I was definitely a binge eater at times in my teens. I'd be really strict one week, and then the next I'd be eating bars of chocolate like it was going out of fashion. I didn't know how to control my eating. If I really wanted something, I would eat it – no matter what restrictions I'd put on myself that day.

I think the difference in the way I eat now is that I'm no longer on a diet. The way I eat now is a lifestyle choice and it's something I do day in, day out, and will continue to do, whereas back in the day I saw foods as 'good' or 'bad'. I would binge when I got bored of dieting, so I'd swing from one extreme to the other. It was hard for me to find a middle ground, and now I have it's such a relief.

/ *'I think the difference in the way I eat now is that I'm no longer on a diet. The way I eat now is a lifestyle choice and it's something I do day in, day out, and will continue to do.'*

I used to get my fitness and nutrition information from different places. Social media wasn't a big deal. You only really had your mates as friends on Facebook, and there weren't nearly as many bloggers and YouTubers around. Because of that most of my tips came via magazines, and reading about how celebrities lost weight. In retrospect I'm not sure how much of it was true.

I remember feeling so insecure and confused because the advice was all over the place, and I didn't know who to listen to. Some people told you to eat carbs but stay low-fat, other people would say high-fat and no carbs. Then there were the no-sugar diets, the high-protein diets, the calorie-counting plans . . . It was never-ending! No wonder my weight was so up and down. Every time I read something new I thought it must be right. But really, if I'd just eaten what my mum was cooking for me every night, I would have eaten a naturally healthy, balanced diet.

I definitely felt pressure to be slim when I was a teenager. No one put it on me, but I felt it myself. And it wasn't just me. All my friends were naturally slim or skinny, and even they were on diets. I look back now and think we all looked really good, but we had no idea at the time. When you're around fifteen or sixteen you do have a tendency to get a bit of puppy fat. You're still in that weird place between being a kid and an adult; it can have a big effect on you, and I guess your mind and body are readjusting. That's how I see it anyway.

I was quite a tricky teen and I was partying from a pretty young age. I started going to clubs in the West End as a young teenager, and because I looked so much older than I was I had no trouble getting in. I wore terrible, terrible clothes. I thought because I had big boobs I had to wear tight tops. I felt like if I wore baggy tops I'd look bigger, so I became a bit obsessed with trying to make myself look smaller. There was no point in trying to hide them, so I decided to embrace them. I must

have looked horrendous! I was obsessed with having a sexy look. I'm not sure what that was about. I think pretty much everything I wore was awful. I had bleached-blonde hair and I'd wear a halterneck bra.

Ridiculously even at that age people would accuse me of having had surgery. I was always being asked which surgeon I'd been to, but anyone that's known me since then knows I've always looked like this. Even now some people are convinced I've gone under the knife. No one believes my boobs are natural, but they honestly are.

Back then drinking didn't seem to affect my weight at all. I think when you're that age you can get away with it. I didn't ever get hangovers or feel bloated. That didn't come until I was about nineteen or twenty. That's when I noticed that if I went out partying too much the weight would go on.

The pounds would go on quickly, but they would come off quickly too. That's slowed down since I've got older, so although I love a good night out, drinking is something I have to be careful of, and it helps that I don't go out anywhere near as much as I used to.

I got part-time jobs as soon as I was old enough to work. My mum gave me pocket money but I liked being able to buy my own things and pay my way, so that was essential for me. I worked as a Saturday girl in a hairdressing salon, I worked in a nightclub selling shots, and I also worked in a fish and chip shop. Thankfully when you work in a fish and chip shop you soon get sick of the smell of fried food and go off it. I ate loads in my first few weeks, but then it totally lost its appeal. That was a blessing because I have no idea how much weight I would have put on if I'd kept eating all the deep-fried 'delights'.

When I left school I got a job as a receptionist in an office near where I lived, which was my first full-time job. I also worked in a pub at the weekends to get a bit of extra money. I liked going out and I liked buying clothes, so I worked hard to be able to afford everything I wanted.

The pub was tricky diet-wise because they let us order whatever we wanted from the menu, and there weren't many healthy options. But I was on my feet for at least eight hours at a time so I was probably working off anything unhealthy I was eating.

At eighteen I got a job in the City, working as a PA in a bank. After a few years, I was working for about a thousand people across the country organizing events, and I loved it at first. That job messed around with my weight because I used to go to the pub with my workmates and drink wine on my lunch breaks, which is the norm in the City. There was a stereotypical 'work hard, play hard' attitude, so it was pretty standard for people to be really strict and get all their work done and exercise regularly, but also have a few drinks every lunchtime. Quite often I'd leave work and meet friends for more drinks, so I was taking in a lot of calories from alcohol. On the positive side there were a lot of healthy lunch options, so I could balance things out.

I was also exercising a lot, and three times a week I would get up at 5 a.m. and go to mini boot camps or classes before work. I was very regimented and if I missed a workout I would panic and my whole day would be ruined. I've definitely got better with that as time's gone on. Now if I absolutely have to miss a workout, I still don't like it, but I'll give myself a break and ensure I make up for it another time. I know now that it doesn't mean I've lost my way completely and that I can just pick it up again tomorrow.

I worked in the City for about five years. My plan B was to start my own bikini business, because I love them. I'm one of those people who always wants to do more and achieve more, and the thought of staying in the job for another five years didn't appeal at all. But of course going out on your own and starting a business from scratch is a big risk, and then when I was offered the opportunity to join *TOWIE* I quit my job.

I did feel very anxious about doing the show but I don't regret my time on *TOWIE* at all. It was a great experience and it opened up other avenues for me. I got to meet new people and I learnt a lot about how TV works, so it was a bit of an education too.

It's hard to imagine going from only being known to your friends and family one day to being recognized by strangers when you walk down the street the next. I'd seen it happen to other people who were on the show, but nothing can prepare you for it. It's very weird that people you've never met suddenly know a lot about you.

My favourite girls

The people close to me really didn't think it would be good for me. They know I'm very self-conscious at times and some of them did say to me, 'Kate, why are you doing this to yourself?' If I'm being honest, I asked myself the same thing.

People start to have this perception of you just from watching you on TV once a week, which I found hard. My friends and family know who I am as a person, as do I, and that's exactly how I thought I would come across. But actually when the first episode I featured in aired I was quite shocked. At the end of the day the show is all about drama, and they need to make it as explosive as possible, but I didn't feel like I was seeing the real me.

There were lots of up and downs, including a break-up, and I was having to deal with them all on TV, which heightened my anxiety. It was uncomfortable and it made me feel nervous when I was filming. I definitely struggled in those early days.

Things did get better. The first few times I filmed I found it hard, but after that I got more used to it, and because I met so many different people I became more confident. It taught me about myself and it opened up my mind to a different world. I had to push myself and challenge some of the things I thought about myself, and I felt a bit braver as a result. I had stepped out of my comfort zone and I was OK.

The only way you're going to know what you're capable of is by pushing yourself. I felt the same when I met Rio. I had no idea if I would be able to look after three kids. People underestimate me sometimes, but I've learnt that if you put me in any situation I can cope. I've surprised myself with what I can do over the years.

I eventually left *TOWIE* because of meeting Rio, and because it felt like the right time. He's got three children, and they quickly became a very big part of my life and vice versa. As a result I had to make a decision about whether I wanted to stay on the show, or whether I wanted to put everything into Lorenz, Tate and Tia.

I didn't feel like it was a good idea to be on a big TV show where a lot of my life was in the spotlight and also try to be step-mum to three young children. It had to be one or the other, and to me the children were so much more important. There was no contest.

Everyone thought I was mad and that I'd lost the plot when I walked away from the show, but if I was going to embrace my new life, I was going to do it properly. I knew it was one hundred per cent the right decision. I took a step back from TV and social media and concentrated on what was more important to me.

/ 'I am safe in the knowledge that we're all really happy and solid, and that's all that matters to me.'

There were also challenges when Rio and I got together, and I had to overcome them. I was trying to step away from the spotlight, but, of course, because of who Rio is I was still in it. People may say, 'Well, you still posted about your relationship on social media, so you chose to be in the public eye.' And, yes, I did put some pictures up. But that's because I wanted to have some control over what was out there, and what was being said about me. It wasn't like I was living my entire life through Instagram. I just chose to share enough to give people an insight into my new life, rather than have them speculating all the time.

People had this image of me as a stupid *TOWIE* girl who was after Rio for his money. They thought I was pretending to look after his children while having secretly hired a nanny. That's so not the case. It's very easy to make assumptions about people, but only you really know what's really going on in your life. I love the kids with all my heart and I look after them every single day. They mean the absolute world to me. If they weren't in my life, it just wouldn't be the same.

I would love to put some of the amazing photos I have of us all together on Instagram, but I value their privacy too much. I have no choice but to put up with the negative comments and things that are said about me to a certain extent, but I am safe in the knowledge that we're all really happy and solid, and that's all that matters to me.

It's funny because I don't really care if people say my dress is horrible or I look awful, because I can handle it much better now. But if someone makes a comment about the children, that makes me really anxious. They're what I care about most, so it really hurts.

My life is so different to how it was a few years ago and I absolutely love it.

'If I end up wearing gym clothes all day, so be it. My life is different now, so I'm going to look different.'

How I look on a day-to-day basis is way down my list of priorities now. People must look at me and think 'Kate looks like she hasn't bothered', but I don't mind one bit. If I end up wearing gym clothes all day, so be it. My life is different now, so I'm going to look different.

I was thrown into being a step-mum. I wasn't pregnant, so I didn't have nine months to get used to the idea of having a child, and then go through the process again with the second and third child. All of a sudden at twenty-six I found myself with three children, and I had to adapt quickly.

Some days I look at photos of the old me all done up and I think 'I need to up my game a bit here', and I will dress up and put make-up on. And I always make a big effort when I go out. But I'm so much more comfortable in my skin that I don't feel the need to look polished every day. It's not reality, and when I did dress up and look glamorous every day I found it pretty exhausting, to be honest. You would think I've got loads of time back as a result of being more low-maintenance, but that time is now spent on the school run!

My weight changed a bit when I first moved in with Rio and the children. I came into a situation that was totally alien to me and all of a sudden I was eating with three kids, and I went with the flow of what they were having.

There were so many other things to think about, so eating right wasn't my main focus. For a while I was too busy looking after other people to look after myself. In the early days for ease I ate whatever the kids were eating, so I was eating a bit too much, and I was snacking when I wouldn't usually have been, like eating crisps

when we were all sat watching a film together on a Saturday night, which is one of my favourite things to do.

Leftovers are also tempting. I used to have my dinner and then mindlessly pick at whatever the kids had left as well. Now if the kids leave food on their plates, I'll put anything that's salvageable straight in the fridge, then I'll throw the rest away immediately so I'm not tempted to pick. Thankfully they're good eaters so they generally finish most of what I give them.

One day I realized that as nice as it had been relaxing my eating habits, it had to stop and I needed to sort myself out. I wasn't happy with what I was seeing in the mirror, and I felt a bit sluggish. I was still exercising, but not to the extent I usually do, and I could really feel a difference. I certainly wasn't huge, but I needed to rein things in again.

> / *'I simply went back to doing what I knew worked, which is moving more, cutting out the daily indulgences, and eating a balanced diet on a daily basis.'*

I felt like I needed that time to get used to being a step-mum and give myself a bit of a break, but then it was definitely time to get back on track. I wasn't treating my body as well as I had been, and I was expecting it to do all the work for me, which sadly it can't do. Enough was enough, so I made sure I got back into a good gym routine and cut back on the treats.

As soon as I did my body went back to exactly how it had been before. I didn't ever go hungry, and I wasn't lying on the floor of the gym crying because I'd overdone things. I simply went back to doing what I knew worked, which is moving more, cutting out the daily indulgences, and eating a balanced diet on a daily basis.

It's really not rocket science. I'm not sure why we make it so complicated!

I'm not perfect, and that's OK!

'IF YOU'RE ALWAYS AIMING FOR PERFECTION, YOU'LL ALWAYS BE LET DOWN, SO LOVE YOURSELF, FLAWS AND ALL.'

I'm not one of those lucky people that was born with incredible self-esteem. It's something I've had to work on my whole life, and I probably will always need to. Like everyone I've had times when I've woken up in the morning feeling amazing and ready to take on the world, but I've also had times where all I want to do is crawl back under my duvet and stay there all day with a giant bar of chocolate.

Being in the public eye brings with it a particular pressure, but we all feel under pressure about the way we look, mainly due to social media. It means we're often comparing ourselves to how other people look and to their lives. But we only see other people's highlight reels, so we'll just see how they look during their best moments. We need to stop comparing other people's best times to all of our times. I wouldn't post a photo of myself with no make-up on when I've just woken up but I will post a nice picture on a night out, so people assume that's my reality. In fact, often my reality is putting my hair up and throwing on a tracksuit to take the dog out. Comparing yourself to other people is the worst thing you can do because you're never going to win. In my opinion we all deserve to feel good. If you don't right now, I'd love to help you make that happen with this book.

I think that self-esteem-wise, things really came to a head for me when I was on *TOWIE*. There was massive pressure about how I looked and I really felt like I was under the microscope. Being on TV makes you so much more aware of everything, and I began to focus on what I perceived to be my shortcomings more than ever.

I've never liked the shape of my legs. Never. No matter how much exercise I do they either stay the same width or if I use weights, my thighs get bigger. I've accepted that's who I am. My natural shape is a long body and shorter legs, and that's not something that's ever going to change.

I know the best bits, and the not so best bits, of my body, so now I concentrate on the good parts and accentuate them. I'll wear clothes that cinch me in at the waist and flatter my bottom half so I look more balanced.

It wasn't like having short legs was a massive surprise to me when I started appearing on TV, but I began to get really self-conscious about them. When I watched myself back I would be critical and think they looked really big. Sometimes I would get caught totally unawares in photos and if it was an unflattering angle, all I would see were my short legs. If it was a really bad angle, I could also easily look a couple of dress sizes bigger than I am. Needless to say I also saw some unkind comments people had made about me online. If you're not feeling great about yourself anyway, they can be a killer. It's never nice for people to point out your flaws.

I can't imagine being a teen now with the way things are with social media. I think I really would have struggled with that when I was already so insecure. These days teenagers have got all the pressures that my friends and I had growing up, but with Instagram, Twitter and Snapchat on top too. It must be a nightmare. At least now I'm older I can deal with trolling from a more level-headed place.

Trolling can still be upsetting at times, but what are you going to do? Unless I delete social media altogether I've just got to get on with it. And of course I chose to put myself out there, and being judged goes hand in hand with being in the spotlight.

Sometimes it doesn't bother me what people say and sometimes it does. It depends on what frame of mind I'm in. I'm more comfortable with myself now. I don't think I look any better but I'm more accepting of myself. I've grown up over the past few years. I've got children now and I've been through a process in which I've learnt what's important, and that's when things shifted for me.

I've got much better at not reading comments. When I first started *TOWIE* I read them a lot. It was like a weird compulsion; I had to see what people were saying about me. The chances are that the people who are writing the really evil stuff have got issues of their own. If someone feels the need to try to upset you, something in their lives probably isn't right. But what they say can still really upset you.

People have even made up stories about me. Someone said a while ago they'd seen me having an argument with a friend of mine in a place I've never even been. I'm sure they just did it to get likes. It was absolute rubbish so I had to let it go.

The weird thing is you don't tend to see the nice comments. You can have thousands of kind words or messages of support, but you zone in on the bad stuff. I don't know why that happens but because I'm happier in myself now I do take on the nice comments too, which is important.

I'm not someone who posts updates every day and needs to have my whole life out there, and that's a good thing because if I do have days where I want to be anonymous I can. I prefer putting up bits here and there, which are inevitably my highlights, because I want to keep some things private. Just because you don't see my ups and downs on social media doesn't mean I don't have them, but of course I won't be posting selfies of myself looking miserable, because that's not what we do!

I've definitely grown to feel better about myself over the last few years. It wasn't as if all my body insecurities suddenly melted away, but because I had faced up to things that scared me and my confidence had grown I felt better about myself so they didn't seem to matter as much. I also accepted my shape. When I realized that no amount of dieting and exercise was going to make me look like a catwalk model I embraced my curves, and I've learnt to love them. I am much kinder to myself, and I work hard to be the best I can be.

One of the lovely things about getting older is that you accept yourself more. You still want to be the best version of yourself you can be, but you work with what you've got and don't strive towards something that doesn't exist. At some point you have to accept that you have flaws and that perfection is not real.

Talking of which . . .

'One of the lovely things about getting older is that you accept yourself more. You still want to be the best version of yourself you can be.'

I HAVE CELLULITE AND THE
WORLD HASN'T ENDED!

I've always had a bit of cellulite on the back of my legs. There, I've said it. I'm not ashamed of it; it's just one of those things, and I refuse to give myself a hard time about it.

I've been pictured a couple of times with dimples on the back of my legs. People were outraged on social media and were saying things like, 'She didn't tell us she had cellulite!' What kind of message is that giving to anyone? To point out someone's flaws like that? Some of the people reading those comments are young and impressionable girls, and they may grow up thinking they've done something wrong if their body isn't perfect. That makes me so sad. Women get cellulite, and I'm a woman. People get stretch marks or thread veins or cellulite, because that's life.

I've got a curvy body so if I put on weight I just look a bit curvier. There were times when I felt pressure to look like I do in Instagram photos at all times but that's not realistic. For instance, having a bloated stomach is something I've got quite used to over the years. I suffer from IBS, and I have done since my teens, so some days I can look like I'm six months pregnant, and sometimes I can have a nice flat stomach, which obviously affects how my clothes fit and how I feel.

My IBS is triggered by stress so if I've got a lot going on it can flare up and my tummy will be swollen and painful. I've tried excluding foods from my diet to see if that makes a difference, and sometimes it does help temporarily, but then I'll get stressed and it's back to square one. Certain foods affect me, like wheat, gluten and dairy, so if I'm having a flare-up, I'll try to avoid them. I know instantly when I eat something if my body is happy or unhappy, so I make sure I listen to it.

/ *'My other golden rule is to drink water, water, water.
I have two to three litres a day to keep my body
moving, and that seems to help with everything.'*

I find that working out can help a lot because it de-stresses me. And I know I have
to take my time when I am eating. If I eat too quickly, that can make me very bloated.
I'm not always good at eating more slowly, but it's something I'm working on.

The other thing I would recommend is aloe, which has helped me no end. I get the
most concentrated one I can and it makes such a difference. My other golden rule
is to drink water, water, water. I have two to three litres a day to keep my body
moving, and that seems to help with everything.

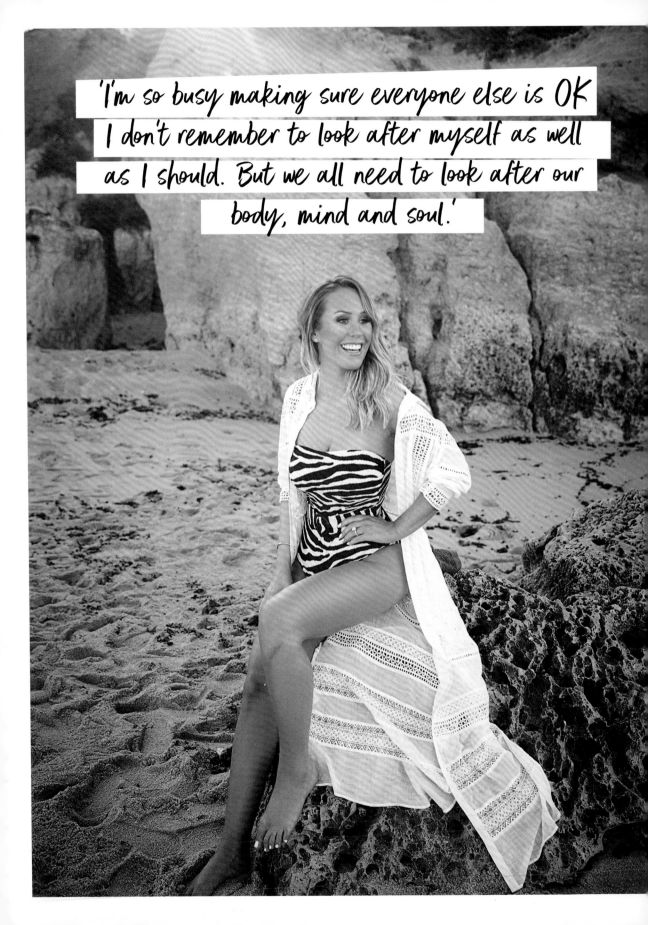

'I'm so busy making sure everyone else is OK I don't remember to look after myself as well as I should. But we all need to look after our body, mind and soul.'

I STILL SUFFER FROM ANXIETY

I think I'll probably always suffer from anxiety. I often battle with what's going on in my head and I struggle to accept myself and my imperfections, but it's something I'm always working on. I've held back from sharing about it too much in the past because I've been worried what people would think, but hopefully by talking about it and being open I can help others.

I'm not a very chilled-out person generally, and I find it hard to relax. I'm going at a million miles an hour all the time and sometimes I'm so busy making sure everyone else is OK I don't remember to look after myself as well as I should.

Exercise helps with my anxiety more than anything else. Ever since I first noticed the positive effect it had on me as a teenager, it's definitely become the thing I turn to if I feel overwhelmed. When I'm in the gym I'm not thinking about other things that are going on in my life; I feel really free and focused, and afterwards I get a real high from the endorphins. That feeling can stay with me for hours, and it can mean the difference between a good and bad day.

I've recently downloaded a mindfulness app, so that's been really helpful too. I try to find time to do it every day, even if it's just for a few minutes.

If my anxiety is bad, it's essential that I avoid things that will exacerbate it. I know for a fact that drinking can make it worse, so the last thing I'll do when I'm having a bad time is go on a night out. I know some people will have a drink to take the edge off how they're feeling, but I know it will make me feel ten times worse the following day so it's just not worth it.

It's more important than ever for me to practise self-care during my most anxious times. I'll go to bed early, I'll exercise and I'll make sure I'm only around people that make me feel good. Sometimes there is nothing better than a big hug to reassure you. The smallest, simplest things can make the biggest difference.

SLEEP IS MY FRIEND

I love sleep. I try to have eight hours a night or I don't feel like I function properly. If I don't have eight hours, I turn into the devil. I like to jump out of bed and I'm a much nicer person if I've had the rest I need.

I like going to bed early and that's something I've done since my teens. I'm a bit like a granny, to be fair. If I go out out, I'm all in, and I won't get to bed until God knows what time. But if I'm having a night in – which I do a lot! – I make sure I'm asleep at a reasonable time. Late nights are not good for me. I like sleep and I like routine.

I'm not nearly as much of a party animal as I used to be. It's not realistic to keep up that kind of lifestyle when you've got kids. I've learnt from experience that trying to look after three children on a hangover is not pleasant. It's definitely getting harder to catch up after a big night out. It used to be much easier and I'd bounce back the following day no problem, but now it takes anywhere from a few days to a week for my body to fully reset itself. I do still have nights out, but now I'll come home and take my make-up off and drink a pint of water before bed.

If the kids go to bed early, I'm quite happy to tuck them in and then go to my room and begin my pre-bed wind down. I like waking up feeling refreshed and I find that if I get a decent night's sleep my head is much less busy the following day. If I have a broken sleep for whatever reason, I can begin to get anxious and overthink things. I also know that if I don't get a good sleep, I'm not going to do a good workout.

Some nights I go off to sleep really quickly and some nights I can lie there mulling things over and it will take me longer to switch off and fall asleep. It drives me mad but I have found a few things that help with that. Firstly I spray my pillow with lavender every night. It's something sleep experts recommend because lavender

'I like waking up feeling refreshed and I find that if I get a decent night's sleep my head is much less busy the following day.'

has relaxing qualities, and it seems to work well for me. Bach's Rescue Remedy, which is a herbal blend of five Bach flower remedies that helps to calm you down, is also great, and I can feel myself unwind as soon as I take it. My mum used to give it to me when I had to do public speaking at school and I've used it ever since. Another thing I like to do is play calming sleep music, but it has the opposite effect on Rio and infuriates him, so I keep that to a minimum! And finally the most important thing for me is to have a notepad and a pen next to my bed. That way if I'm lying in bed thinking about things, like the fact I've forgotten to get salmon out of the freezer, I'll write them down so they're not going round and round in my head and driving me mad. It's like a little to-do list and once they're out of my head I can rest more easily. I can then look at the notepad the following morning and it will remind me what I have to do.

I do keep my phone by my bed, but I try to stay off it before I go to sleep, and I won't ever look at it to find out the time if I get up to go to the loo in the night. I just know if I look at it and think 'I've got to get up in two hours' I won't be able to get back to sleep. I'm very strict with that.

I'll also put my phone on flight mode if I want to have a break, and I will only reply to work messages between work hours, otherwise I can still be emailing people back at midnight and that's not healthy.

I STILL SUFFER FROM BREAKOUTS

Having had acne since I was thirteen or fourteen, I make sure I take really good care of my skin. Thankfully I no longer get acne like I used to, but I do still get hormonal flare-ups on my chin around that time of the month. I might also get a few spots if I'm stressed, but I'm lucky that my skin seems to have balanced out.

I think getting your skin into a routine is such a good thing, and if you look after your skin it does show. You can get away with using face wipes and a bit of moisturiser when you're in your teens, but when you get older you have to be kinder to your skin.

I go through a routine every night and morning where I cleanse and then I use eye serum, glycolic acid, vitamin C, firming serum and then finally moisturizer. I also put sun cream on every day to protect my skin, even if it's raining outside.

I felt like my skin was getting a bit dull for a while and then I found an amazing lady called Bianca and she has changed my life. I have facials with her every two or three weeks now and they refresh my skin and help to heal any sun damage I've had in the past. I didn't use to think about protecting my skin when I went out unless it was really sunny or I was on holiday. I'd whack on a high-factor when I was sunbathing and think that was doing the job, but now I know better. Even if it's a really overcast day, the sun can still do a lot of harm to your skin.

I always take my make-up off, no matter how tired or drunk I am. I know for a fact that if I don't take my make-up off I'll wake up the following morning with spots, so it's not worth trying to get away with it. Nine times out of ten I'll still do my whole routine. Rio finds it hilarious because I can be in the bathroom for about fifteen minutes if I'm doing it really thoroughly.

Not wearing any make-up has also had a really positive effect on my skin. I think that's why I probably only wear it once a week now, if that. I'll just stick some sunglasses on and hope no one sees me!

If I'm having a night out, I'll go through the full process. I go full-on glam and it takes me about forty-five minutes. I enjoy it because I'm not doing it every day, and it's nice to go through that transformation. Mind you, it's not as easy for me to do that as it used to be. I didn't use to have to think about getting ready for a night out. It was a breeze. But when you've got three kids who want to be in the room asking questions, it takes twice as long. Sometimes I have to say to them, 'Right, just give me an hour and I'm all yours again.' That doesn't usually work, though.

I've definitely got better at doing my make-up over the years. When I was younger, I felt like I had to up my game to fit in, so I went to see a make-up artist. She did my face for me and gave me a proper lesson. I learnt a lot from her, and after that I felt more confident about doing my own make-up. The best tip I picked up is to always wear a primer. I didn't do that before and I couldn't understand why my foundation used to go patchy. I also use a spray during the day that refreshes make-up. You literally spritz it on to your face and it perks everything up again.

I keep my body skincare routine very simple. I shower twice a day and then I moisturize my whole body. I don't use anything fancy; it's usually just cocoa butter, which smells amazing and really does the job. I don't believe you have to spend a fortune to get the best body creams. Some of the most basic, reasonably priced ones do the job just as well.

LOOKING AFTER MY SKIN

Of course, us Essex girls are known for wearing fake tan, and I must admit I started wearing it pretty young. Back at school mine used to be really patchy because I wasn't great with the whole exfoliating and moisturizing thing. But to be fair everyone else's was too, so I didn't mind. As long as I was tanned it didn't matter.

I also (and this is a terrible thing to admit) used to go on sunbeds. I know. They're so bad for you and I wouldn't dream of doing it now. I was also underage, so the salons shouldn't have let me go on them. Sometimes I would go four times a week, which absolutely horrifies me now. All my friends were doing it too, so it was the norm and I honestly didn't know, or think about, the risks. I'm so glad I've educated myself about it all now. I would never, ever go on a sunbed now and I wouldn't recommend them to anyone. But back when I was a teen having a tan was the be-all and end-all and there were salons everywhere around where I lived.

Amazingly I'm not even that much of a fake-tanner now. I use the gradual moisturizer ones sometimes and I have the occasional spray tan, but I'm not as obsessed with it as I was. I feel like you've got two options: you can either be tanned all the time and look older and know that your skin will suffer, or you can be lightly tanned by using a gradual tan, but know that your skin will be better off in the long run.

I'm not a great sunbather. I get really bored and after twenty minutes I end up walking around moaning and trying to do something to keep myself occupied. I'll be in and out of the pool all the time, or chatting to people. I'll do anything to break the monotony. The kids really like the fact that I can't sit still because it means they've always got someone to play in the pool with.

When I came back from my latest holiday I'd been playing with the kids so much I hardly sunbathed at all. The taxi driver who collected me from the airport said, 'Where have you been? You don't look like you've been somewhere hot.' I think that says it all!

When I do sunbathe I use a really high-factor sun lotion. In my teens I used oils with a really low factor because I wanted to be as brown as possible, but now I am as safe as possible. Staying healthy is so much more important than being tanned.

I LOOK AFTER MY HAIR

I first got hair extensions in my late teens and, after a few bad experiences where I was even left with bald patches as hair was ripped out, I decided I needed to give my hair a break. For a while I was also tonging my hair most days so it was really dry and brittle and looked terrible. I had been so caught up in a world where I had to look a certain way that I didn't always take proper care of myself.

I often take the extensions out over the summer and I'm much more careful with what I have. I don't pack my head full of them anymore, as I prefer a much more natural look. Instead of having a hundred extensions, I'll just have twenty-five to thicken it up.

I had a fear of taking out my extensions because I'd had them in for so long and I thought my hair would look awful without them. But in the end my hair started falling out so my hairdresser told me I had no choice but to get rid of them.

I honestly feel so much better since they've gone. My hair is growing again and I no longer bleach it like I did. I only need to dye my hair a couple of times a year and I sleep in Olaplex, which is an intensive hair treatment, once a week, so it's finally getting back into better condition.

The kids said to me that I'm so much more fun on holiday when I don't have extensions in because I would go under the water in the pool. Last year I was so worried about my extensions that I didn't want to get my hair wet. This year we were having handstand competitions and all sorts. I tend to wear my hair in a bun most of the time because I try not to wash it as often, and it's also really convenient for the gym.

It's funny because I used to think that taking care of yourself meant wearing tons of make-up, fake-tanning and putting loads of hair extensions in, but now I've gone back to basics I feel so much better. I like being more relaxed about how I look. I'm not looking to impress anyone. I used to worry about being caught out by the paps in case I looked a total state, but now I think 'So what? I'm only human'. If I'm in a rush or I'm walking the dog, I'm not going to put make-up on in case someone is lurking in the bushes trying to get a dodgy shot of me. I'm over all that. My hair and skin are probably the best they've ever been and that's because I'm being kinder to myself. I may not look as glamorous but I feel so much better.

/ *'I've gone back to basics I feel so much better. I like being more relaxed about how I look. I'm not looking to impress anyone.'*

I'VE LEARNT TO DRESS FOR MY BODY

Another thing that's got better as I've got older is my style and my understanding of what suits me. I've always dressed for my figure, but I often had too much cleavage out and in my teens I definitely didn't follow the rule of either having your legs or boobs out. Quite often I'd happily do both.

I've learnt what suits me and what doesn't clothes-wise over the years. I've found my style and it's no longer always about being sexy. I don't feel that pressure any more, but that's only happened in the last year or so. I think that's because I'm not in the public eye so much, so I don't have to follow any rules. What's important to me has changed. Dressing up and going out aren't as important to me as they were. Now I really only make a proper effort if I'm going to something special.

I don't enjoy shopping, which always amazes people. I would much rather someone did it all for me because I find it really stressful. I dream of someone buying all my clothes for me and coming round and laying them out every night so I know exactly what I am going to wear the following morning.

I think part of my problem is that I sometimes find it hard to find clothes that fit me. I had a big chest and a small waist in my teens, so I could never get dresses that looked right and I'd have to get everything altered, which was a pain. I still have to get a lot of clothes altered, and I went through a phase of wearing loads of co-ords because they didn't need altering. But it is still worth having a nice dress altered so it looks just right.

I've never been the kind of girl that follows fashion religiously and wears everything that's on-trend. There are some things that will look amazing on a supermodel, but potentially a little bit ridiculous on someone who isn't six-foot tall and a size eight. I don't feel that pressure to wear every new thing that's in fashion magazines.

I've become a lot more relaxed and casual with my clothes. I think when you're younger you want to look sexy, but once you feel settled in a relationship, that becomes so much less important and you want to wear what you feel happy and comfortable in.

I didn't wear jeans for about ten years. Some of my friends thought I was mad because they live in them, but at some point I convinced myself I looked fat in them and that was that. I've finally realized I was being ridiculous and started wearing them again, but even now my mates are shocked if I turn up in a pair.

One thing you won't often see me in is shorts. I'll wear them to the gym but you would rarely catch me wearing them out and about. Every now and again I'll wear a short dress, but generally you'll find me in something long because I don't like my knees. If I'm wearing something short you know I'm feeling good.

When it comes to gym clothes I like to be comfortable. I'm not going to the gym to show off or look good. Who does look good when they're running around looking sweaty? The gym is somewhere I go to get fit and feel better; it's not somewhere I go to be seen.

I tend to wear black gym gear most of the time because it's easy, it's flattering and it means everything you've got matches! I do embrace colour sometimes but black makes me feel good. And if I feel good, my mind isn't distracted and my workout is going to be good.

Not surprisingly I don't care about my hair or make-up one bit when I'm working out. I often wear a cap, and I'm definitely not one of those people that goes in to the gym looking sleek and comes out looking just as good. I would feel like I was cheating myself.

At the end of the day I don't go to the gym to impress anyone. I'm there to put in the work, which isn't always that pretty!

'I've learnt what suits me and what doesn't clothes-wise over the years. I've found my style and it's no longer always about being sexy.'

I love food!

'*FOCUS ON THE GOOD.*'

When Rio and I first started dating he said to me, 'You're not one of those girls that doesn't really eat a lot, are you? You know, someone that just lives on salad?' I found that hilarious. I remember laughing and saying, 'Just you wait.'

When we went out for our first proper dinner date I ate all my main course and then finished off his steak. I think he was a bit shocked, but he's never questioned my eating habits again!

Some people assume that because I'm into fitness I'm really regimented or I don't eat, but that's so not the case. I love food. It's one of my real pleasures in life and that's why I make sure I savour every mouthful.

Loving food doesn't have to mean indulging in burgers every day; it's about learning how to make healthy choices and enjoy them. There is absolutely no point in eating foods you don't like because you're on a 'diet' and think you should have them. That's like torture. You'll only end up feeling resentful and reaching for a bar of chocolate.

To me a balanced diet means having treats every now and again. Sometimes at the weekend I'll have sweets and crisps with the kids while we're watching a film and I won't berate myself for it. I'm realistic, and I know that I can't be super-strict or I'll go a bit mad.

I wasn't always like this. There were times when I was so stressed about what I was eating I would get myself in such a state. It was so hard to step away from the quick-fix fads because I was anxious about putting on weight. If I knew I had to go to an event or something and I wasn't feeling good, I'd be desperate to discover something that could magically make me lose half a stone in two days. But I quickly learnt that those things do not exist.

'I've learnt that the worst thing to do when you put on a bit of weight is panic and feel like you've lost control. You haven't because you are in control. Now I always remind myself that weight gain is temporary and it's not the end of the world.'

The thing is if you starve yourself for a month before your holiday and then go away and eat fry-ups and ice creams every day, you're going to put on everything you've lost and probably a bit extra too. But if you feed your body well most of the time, it's going to support you when you indulge, and any weight you gain will go when you get back to your normal routine.

I've learnt that the worst thing to do when you put on a bit of weight is panic and feel like you've lost control. You haven't because you are in control. Now I always remind myself that weight gain is temporary and it's not the end of the world. I fall off the wagon with my food sometimes because life happens, but as long as it doesn't become a long-term thing it's not a huge problem.

SELF-CARE IS KEY

No one can manage my mind and my feelings except me. Yes, external factors play a part, but at the end of the day, no matter how much advice I read on Instagram from fitness gurus, only I can keep my mind in the right place where I look after myself and feel good.

If I'm in a negative frame of mind because I've eaten badly, it's too easy to stay there and think 'Well, I'm in this now, I may as well carry on'. It's up to me to change those thoughts and also remind myself that having a bad day doesn't mean I'm going to wake up twice the size the next day. That's not how it works.

I like to go out and enjoy myself when I can and I'll relax and eat what I want. What I won't then do is berate myself, feel guilty and end up eating badly for the rest of the day. If I'm really hung-over, I some-

/ 'No one can manage my mind and my feelings except me.'

times end up eating absolute rubbish. But I know when I wake up the following morning that binge is not continuing. I will wake up with a fresh mind ready to work out and redress the balance, and I'll eat that bit more healthily that day.

It's easy to get ourselves into the mindset of being either 'on' a diet or 'off' a diet. That means we either want to stuff our faces with rubbish 'because we can', or torture ourselves by trying to eat as little as possible. Clearly neither of those approaches work. The only approach that works is self-care, and that means eating healthily most of the time, but allowing ourselves to live a little too. If you eat right and train right, you really can't go wrong.

I know it's a cliché, but if you lose weight slowly and mindfully and sensibly, you will be able to sustain that way of eating, meaning you will keep that weight off long-term.

Am I on a diet every day of my life? No. But do I watch what I eat? Yes.

It doesn't have to be feast or famine. You don't need to be eating lettuce for breakfast one day and a Twix the next; you just need to be balanced and aware of what you're putting in your mouth.

I keep my eating steady and I do my best to stay in a routine, but I can't always do that. If I go on holiday or I have a phase of going out a lot for friends' birthdays or meet-ups, I do feel the pounds creeping on. Do I have a moment of panic sometimes? Of course. Do I then rush out and buy weight-loss tea that promises I'll lose half a stone in days? Absolutely not, because I know the reality is unless I lose the weight sensibly I could fall back into the yo-yo dieting trap.

It is honestly better to be a few pounds heavier for a couple of weeks and allow your body to lose the weight in a kind and gentle way than deplete it of the things it needs. I've put on weight on holidays and come back feeling a little disheartened, but I know that once I get back into my normal routine the wine weight will go in no time. And it does.

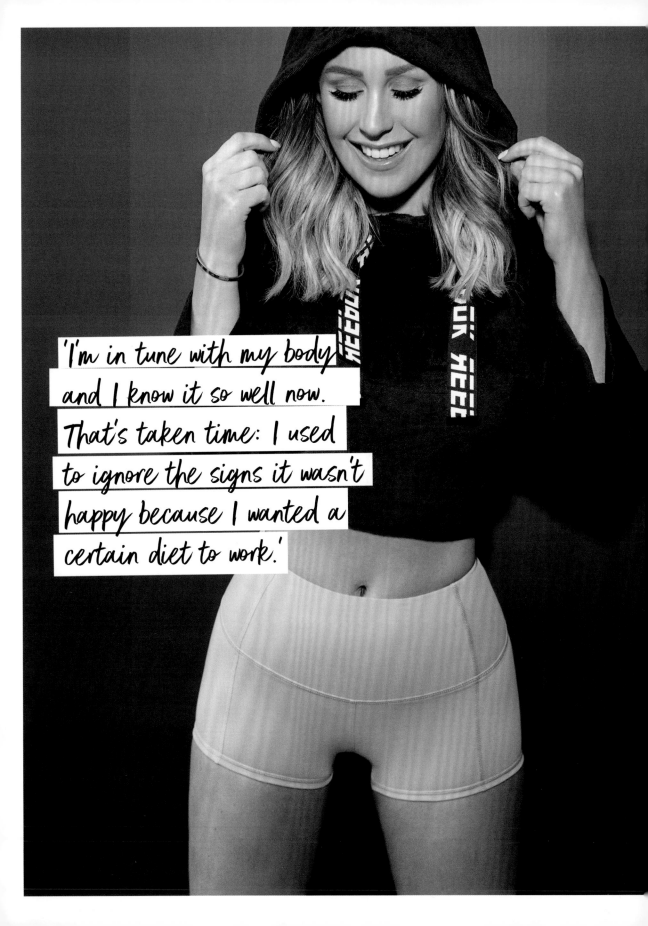

'I'm in tune with my body and I know it so well now. That's taken time: I used to ignore the signs it wasn't happy because I wanted a certain diet to work.'

I'm in tune with my body and I know it so well now. That's taken time: I used to ignore the signs it wasn't happy because I wanted a certain diet to work. It's been about trial and error and I tend to listen to myself rather than what the latest expert is trying to tell me. You know if something gives you more energy or if it makes you feel tired, and just taking a few moments to notice can make a huge difference to your health and well-being.

You know your body better than anyone. I know that some people will follow whatever's on-trend that week or whatever people are blogging about, but I never eat things I don't like just because I think I should. When the green-smoothie craze kicked off I tried it, of course, but I learnt really quickly that doesn't work for me. Some ingredients give me a dodgy belly and bloat me. I also find the intense hit of sugar too much. I get a burst of energy and then I crash. Some people have the same reaction but they carry on regardless, because we've all been told it's the secret to quick weight loss. I've learnt that just because something works for someone else, it doesn't mean it's going to work for you.

I've noticed that since I've hit twenty-five I've found it harder to lose weight. I think that's a really common thing, and it's known that as you get older your metabolism changes and it becomes harder to lose or maintain weight. I feel like up until twenty-five I could get away with eating a little bit more, and I could snack and not worry about it. Now I'm more aware of what I put in my mouth, from both a wellness and an empty-calories point of view. When I was younger I would have a crisp binge and then spend three times as long in the gym to work it off. Now I weigh up what is and isn't worth letting myself go for. A lovely meal out with great friends? Worth it. A random crisp binge that's way less fun? Not worth it.

I'M NOT THE GREATEST COOK

I'll be honest, Gordon Ramsay isn't about to beg me to go and work in one of his restaurants, but I have got a lot better at cooking because I have to make sure the kids get proper meals.

I've definitely improved since I met Rio, and I've expanded the range of dishes I make. I used to cook what I like because I was only cooking for myself, but now I make things that the kids like and they're proper family meals like salmon and rice and broccoli, or prawns with rice and veg, or lamb chops, potatoes and veg. They always have greens with their dinner.

I make everything from scratch, because then you know exactly what's in your meals. If Rio's working, I'll cook for the kids, and if he's not, we'll take it in turns.

Whenever I learn a new recipe you can guarantee I'll roll it out pretty regularly for the first few weeks. Then I'll get bored and move on to something else. I'm a creature of habit. I will happily eat the same thing day in, day out for a couple of weeks, then I'll get bored of it and move on to something else. But I always stick to the basic foods I like and that I know are good for my body. It's so much fun learning new recipes and I feel a real sense of achievement when I master something new. I make an amazing shepherd's pie now and the kids love it.

I still eat with the kids sometimes, but I'll tailor it to me. For instance, instead of having shepherd's pie I'll have the shepherd's pie with veg and sweet potato and they'll have normal potatoes. Or if the children have steak and chips, I'll have steak and spinach. It means I'm still eating well but I'm not always making multiple meals. I also cook a good roast on a Sunday, and I'll say I won't have the roast potatoes but I often do.

A TYPICAL DAY'S DIET

I do try to mix up what I eat so I don't get too bored, but I would say a typical day's diet for me looks something like this:

BREAKFAST:

If I'm training first thing, I'll train on an empty stomach but I will have a green tea first. Breakfast is usually a protein shake or scrambled eggs, smoked salmon and avocado.

LUNCH:

If I have a big breakfast, I wouldn't then have a big lunch, but if I have had a protein shake I will. I try not to have carbs at lunchtime, so I'll have something like chicken and vegetables, or scrambled eggs or an omelette.

DINNER:

The main things I eat are white meat and fish with veg with a healthy carb on the side, like brown rice or sweet potatoes. When it comes to vegetables I only like spinach, carrots and broccoli and kale if it's chopped up into small pieces, so I'm quite fussy, but I find ways to make sure my diet is balanced. I also love stir-fries with chicken, or fish or chicken with brown rice and spinach.

If I've had a big lunch with carbs, I won't have carbs with dinner, so I may just have salmon and veg. I balance it out. If I've had a lunch out and I'm not that hungry, I may just have a lighter meal and occasionally a shake. If I go out for dinner, I'll eat whatever I want and I don't worry. I'll have bread, a starter, a main, dessert and cocktails, but I will be more careful the following day.

SNACKS:

I don't ever factor snacks in, but if I really want something I'll snack on bananas or rice cakes with cream cheese. In fact, I'll sometimes have that as a small lunch. We always have fruit in our house because we like the kids to eat it, so I will snack on that, but I don't tend to eat in between meals a lot these days because I have better-sized portions and I don't eat for the sake of it.

DESSERT:

I'm not a big dessert person, but I do love strawberries, so if the kids are having strawberries and ice cream I may just have the strawberries. I also like sticky toffee pudding and custard as a real treat every now and again. We don't have desserts as a family every night, but we will have one after our roast on a Sunday.

DRINKS:

On a day-to-day basis I only really drink green tea, aloe and water, but I love going out and having a drink with my friends every now and again. I adore wine and cocktails, but if I feel like I've been indulging too much, I'll stick to vodka, though I won't drink it with sugary drinks. I like food too much, so I'd rather eat my daily calories than drink them!

I find that if I have a green tea with my meal it helps me to digest it more easily. That may not work for everyone, and some people don't get on with green tea, but it seems to really suit my body. Even if I've had a big meal out with wine or cocktails, I'll end the night with a green tea because I feel like it helps my body to process the food better. I'm not saying that from an expert point of view, that's just my experience.

I tend not to eat pasta and I keep white potatoes to a minimum. I don't have any milk. I don't even have milk alternatives because I don't drink tea or coffee and I rarely eat cereal, so if I'm having porridge I prefer to use coconut milk, as in my recipe on page 74.

I've never been one of those people who likes milky coffees, which is a good thing. Some of the coffees you can buy now have the same amount of calories as an entire meal. It's crazy. People are having three meals a day and then coffees on top, so it's no wonder we're putting on weight as a nation!

I very rarely drink fizzy drinks because they bloat me. I'm not one of those people who thinks I can eat a massive pizza with a Diet Coke, and the Diet Coke will cancel out the pizza!

I do eat bread occasionally, but I know it's not good for my IBS so it's a real treat. If I go out for dinner, I'll always have gluten-free bread.

Even though I'll have bread on occasion, one thing I rarely eat is sandwiches. I never feel like there's any goodness in them. The only ones I do have sometimes are the Christmas sandwiches with turkey, stuffing and cranberry. I may have one once a year as a festive treat, but that's my lot.

I'm not a big fan of basic salad ingredients, like tomatoes and cucumber, so I try to keep them interesting and filling with things like salmon and butternut squash – recipes on pages 90 and 93. While salads like these are genuinely great for you, some are hugely unhealthy, so you do have to be careful. Some of the ones you get in restaurants have got more calories than a pizza!

What I've learnt along the way

'I'VE ALWAYS LOVED THE IDEA OF NOT BEING WHAT PEOPLE EXPECT ME TO BE.'

DON'T OBSESS OVER LABELS

I used to be one of those people who constantly looked at food labels so I could find out the calorie and fat content of everything, but now I eat a balanced diet I don't feel the need to do that any more.

The thing is if you go on a calorie-controlled diet it can be a licence to eat rubbish. If you restrict yourself to 1,200 calories a day, for instance, you could legitimately eat six chocolate bars. In fact, when I was younger I had a friend who went on a calorie-counting diet. All she ate was chocolate biscuits and she couldn't understand why the weight wasn't dropping off and why she felt so tired all the time. Her poor body wasn't getting any of the nutrients it needed. It was probably holding on to anything she was putting into it because it was panicking.

We don't need to look at the backs of packets to know if what we're eating is good for us or not. If you're realistic about what you eat, you know what's healthy and what isn't. If I'm going to treat myself and eat a chocolate bar, I'm not going to then look at how fattening it is; I'm going to enjoy it. As long as I'm not eating it every day it's OK.

ONLINE SHOPPING IS A WIN

I've learnt over the years that online shopping is so much better when it comes to eating healthily. It's too easy to get tempted by the foods that are bad for you when you go into a supermarket. All the really tempting things tend to be right near the tills, so you end up popping a few into your trolley without even thinking about it.

Because of the kids it's impossible for me to go shopping and avoid the aisles that are packed with sweets, crisps and chocolate. And I swear something happens to me when I'm around all those foods. There are always buy-one-get-one-free deals, and before I know it I've stocked up on a load of things I didn't mean to buy.

The good thing about online shopping is that unless you actually search for the naughty foods and add them to your list, they're not going to end up in your shopping basket. If your order turns up and there are eight packets of chocolate biscuits and a bumper pack of crisps in one of the bags, you're going to know why.

I love the fact you can save things in your online basket and add them week after week and add or remove things as needed. I tend to know what I'm cooking for the week on a Monday because it's important to plan when you're cooking for children, so I'll only buy the ingredients I need.

I know it's much harder to shop online if you're just cooking for yourself or for you and a partner, because then people often tend to shop as and when they need to. But this is where the genius of batch cooking comes in. I know it's really obvious, but making more food than you need means you've always got something healthy to grab. And just because you make a few extra portions it doesn't mean you have to eat the same thing day after day. If you've got a selection of home-cooked food in your freezer, it's like having your own healthy ready meals to hand.

DON'T TORTURE YOURSELF WITH TEMPTATION

I have to be strict with myself about things like biscuits and bars of chocolate. I know that once that wrapper is off I'll eat the lot. I'm not the sort of person to eat one square and put the rest back in the fridge. I would certainly never buy a family-sized bar of chocolate because it would disappear too quickly; instead I'll buy myself a little bar as a treat. I have to do that because if it's in the house, I'll eat it. I know what my weaknesses are.

There are often naughty snacks in the house for the kids but I keep them in a high cupboard out of reach of both the kids and me. If I have a sweet craving, I've got to get out a pair of mini steps and climb up to get them down. As soon as I go to get the steps I think 'Why am I doing this?' and it stops me. Because it's a bit of a process to get to the chocolate it often stops me from indulging. But not always!

DON'T STRIVE FOR PERFECTION

Everyone struggles sometimes, and if you feel like you've failed at being healthy in the past, it could just be that you've been putting too much pressure on yourself or been unrealistic about what's achievable. The beauty of this programme is that it's sensible enough for you to stick to, and you're not going to be depriving yourself in any way.

HOLIDAYS DON'T HAVE TO EQUAL DIET DISASTER

The first thing that goes for me on holiday is the food. I'll still work out while I'm away, but when you're lying on a beach having a lovely time sometimes you just want an ice cream and to not feel like you've committed a sin. Just don't do it every day!

We go out for dinner most nights on holiday, which I love because family time is really important, but if I know we're eating out I won't have a massive breakfast and lunch that day and I'll make sure I do a few extra laps in the pool. Simple.

BEWARE OF BUFFETS!

I would always rather order from a menu than go to a buffet. I think all-inclusives are tough. Ordering from a menu means you take time to think about it, whereas with a buffet you tend to get confused and throw everything on your plate to try to get your money's worth. You get carried away and end up eating more than you mean to.

BE PREPARED

There are times when I'm really well prepared and there are times when I'm not. For instance, if we go bowling as a family and I know the kids and Rio are going to eat rubbish food, I might take a protein shake with me or eat first. When I don't I always end up eating chips, which I don't want to do too often! Obviously it's not always possible to be that organized, but a bit of forward planning can make a huge difference.

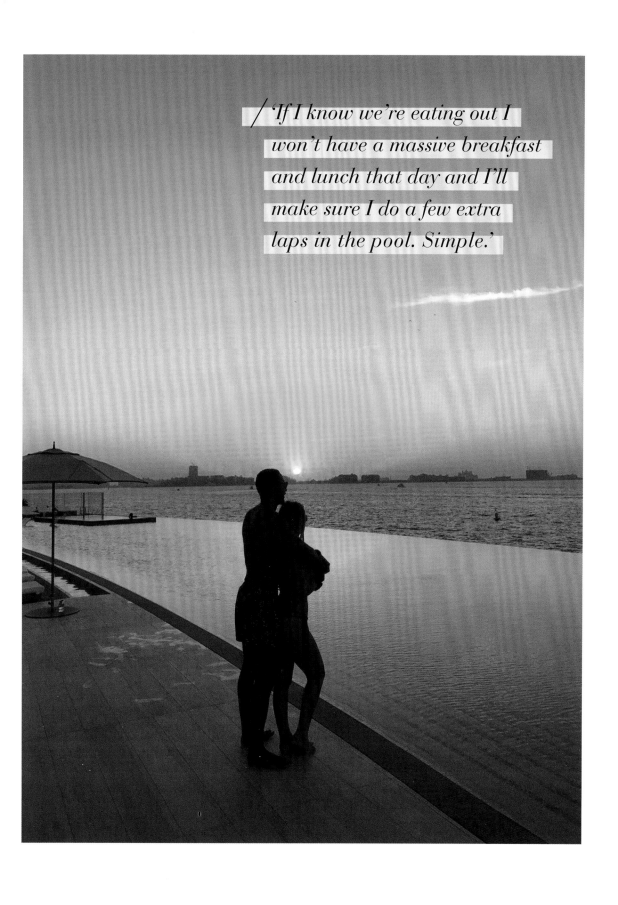

/ 'If I know we're eating out I won't have a massive breakfast and lunch that day and I'll make sure I do a few extra laps in the pool. Simple.'

KEEP A FOOD DIARY

Something that I've found really helpful at times is writing a food diary. It's a good thing to do if you think you're eating something that doesn't agree with you, or you just want to keep track of what you're putting in your mouth. That way you can't get away with eating things and then 'forgetting'. You have to be totally honest with yourself.

Another thing that's really worked for me is taking a photo of my food before I eat it (not for Instagram purposes, I might add). I create a special folder in my photos app so I can look back and see what I had and when. I even coupled up with a friend a few years ago and we agreed that we would swap photos of every meal. At the end of the day you already know if you're eating something bad, but when someone else points it out to you there's no denying it!

KNOW WHEN TO STOP

I've got much better at knowing when I'm full, but it's something I used to be terrible at. I'd always finish all the food on my plate and then afterwards I'd think 'Why did I do that?'

Eating more slowly (not one of my talents) helps because you're more aware of when you've had enough. We all know it takes a while for our brain to know our stomach is full, and it's too easy to keep going and then regret it afterwards. You don't want to overload your body. It's got to process everything you eat and piling too much food in is going to make that harder.

It's difficult because we're often brought up to finish what's on our plates, but we have to listen to our bodies. Your body is not a bin, and you can put leftovers in the fridge and have them another time. If you overeat, you'll only end up making yourself feel ill and miserable.

/ 'I know it's a cliché, but if you lose weight slowly and mindfully and sensibly, you will be able to sustain that way of eating, meaning you will keep that weight off long-term.'

DON'T GO HUNGRY

On the flip side of that I don't ever let myself get too hungry. If I do I'm tempted to grab the easiest and quickest thing I can find to satisfy my hunger, and nine times out of ten that will be something unhealthy. You're much better off having a banana to keep you going until your next meal than ending up feeling like you want to eat the world.

STEP AWAY FROM THE SCALES

I used to weigh myself all the time when I was younger, but so many things can affect your weight, especially the time of the month. I'd get on the scales, look down and feel instantly depressed. If I'd put on a few pounds, it could honestly ruin my day.

I stopped weighing myself a few years ago and now I track my weight through photos, clothes and how I feel. There were times when I was working out a lot and I'd feel amazing, then I'd get on the scales and I'd be a few pounds heavier because muscle weighs more than fat. Even though I knew I looked better it still got me down.

I would recommend taking progress pictures in your underwear or a bikini so you can see where you're at. I've done that before and it's been really helpful. It's a much better indicator of how your body is reacting to eating well and working out than a number on a dial.

The bottom line? If you look after your body, it will look after you.

Chapter 2
FOOD

I've tried to keep these recipes really varied so there are lots of options if you're not a big fan of certain foods or if you know something won't agree with you. It's about what's going to make you feel good.

There are no set rules, aside from making sure you have protein with every meal. You can mix and match the dishes as you like. As long as you feel full and satisfied, that's the most important thing.

Simple food rules

I don't follow a really strict set plan with my eating, but it is very important that I eat a healthy, balanced diet. The bottom line is that we all need to get good things into our bodies in order for them to work properly, so it's essential we have a combination of protein, carbohydrate and fat, as well as vitamins, minerals and fibre. We can do that by eating unprocessed whole foods – which basically means foods that are as close to their natural state as possible – and avoiding crisps, cakes, biscuits, fizzy drinks and fast foods, which contain a lot of calories but not a lot of goodness.

Ideally we should aim to eat a minimum of five portions of fruit and vegetables a day because they're packed with nutrients that promote healthy immunity, skin and hair. If we do that, not only will we feel good, we'll look good too!

People often talk about how great a traditional Mediterranean diet is, and there's a good reason for that. It's naturally balanced and includes a lot of fruit, vegetables, fish, beans, lentils, whole grains, nuts, seeds and olive oil, all of which are packed with nutrients and fibre. It's also rich in unsaturated fats, and healthy unsaturated fats are our friend. We need to focus on the 'good' fats found in olive and rapeseed oil, oily fish, avocados, olives, nuts and seeds, and steer clear of the saturated fats found in butter, red meat and coconut and palm oil.

'Ideally we should aim to eat a minimum of five portions of fruit and vegetables a day because they're packed with nutrients that promote healthy immunity, skin and hair.'

HOW TO BUILD A BALANCED MEAL

The simplest way to put together a balanced meal is to include a portion of protein-rich food, a carbohydrate-rich food, some vegetables or fruit, and healthy fats.

Your meals should include:

A palm-sized amount of protein-rich food,
e.g. chicken, fish, meat, eggs, cheese or beans.

A clenched fist of carbohydrate-rich food,
e.g. potatoes, rice, pasta, bread or oats.

Two handfuls of non-starchy vegetables or fruit,
e.g. broccoli, carrots, peppers, spinach or berries.

A thumb-sized amount of healthy fats,
e.g. olive oil, rapeseed oil, nut butter.

HEALTHY FOODS TO INCLUDE IN YOUR MEALS

Protein-rich foods	Carbohydrate-rich foods	Vegetables and fruit	Healthy fats
Lean meat	Potatoes	Spinach	Olive oil
Chicken	Sweet potatoes	Peppers	Rapeseed oil
Turkey	Brown rice[4]	Broccoli	Olives
Oily fish, e.g. salmon	Wholegrain bread[4]	Butternut squash	Nuts
White fish, e.g. plaice	Wholewheat pasta[4]	Carrots	Nut butter
Tinned fish, e.g. tuna	Oats	Cauliflower	Seeds
Prawns	Quinoa[4]	Cabbage	Tahini
Eggs	Sweetcorn	Courgettes	Avocado
Milk (dairy or soya)[1]	Wholewheat tortillas and pitta bread[4]	Onions	Oily fish
Plain Greek yogurt[2]		Asparagus	
Cheese		Kale	
Tofu		Strawberries	
Tempeh		Blueberries	
Beans		Raspberries	
Chickpeas		Blackberries	
Hummus		Oranges	
Lentils		Kiwi fruit	
Peas		Bananas	
Quorn		Cherries	
Quinoa[3]			

1 Whole, semi-skimmed and skimmed milk and soya milk contain similar amounts of protein, but non-dairy milks (e.g. almond and coconut) contain significantly less.

2 Greek yogurt contains twice the protein of ordinary yogurt because it is strained.

3 Quinoa is a good source of both protein and carbohydrate.

4 Choose mostly wholegrain varieties as they are richer in fibre, B vitamins and iron than white versions.

Breakfasts

Porridge with coconut and raspberries

PREP TIME: 5 MINS

COOKING TIME: 5 MINS

SERVES: 1

Mix the oats and milk in a saucepan. Bring to the boil, turn down the heat to a simmer and cook for 4–5 minutes, stirring frequently. Add some of the raspberries at this point if you like them mixed in.

Once you have the consistency you prefer, pour into a bowl and top with the raspberries and desiccated coconut.

40g oats

250ml coconut milk (or any other milk of your choice)

A handful of raspberries, fresh or frozen

1 tbsp desiccated coconut

Takes minutes, looks impressive!

GF (if using GF oats) VEGAN /

Blueberry and cacao overnight oats

PREP TIME: 5 MINS

SERVES: 1

Put all the ingredients in a bowl and mix together. If you'd like blueberries mixed in, crush and add some here.

Transfer to a wide-necked container or jar. Close the top and refrigerate overnight.

In the morning remove from the fridge and top with extra blueberries and cacao nibs.

40g oats

75ml milk (any type)

125ml low-fat plain Greek yogurt

2 tsp honey or maple syrup

½ tsp vanilla extract

A handful of blueberries

1 tbsp cacao nibs or dark chocolate chips

The perfect way to kick off a morning.

GF (if using GF oats) V

Nutty granola

PREP TIME: 5 MINS

COOKING TIME: 40 MINS

MAKES: 10 X 50G SERVINGS

Heat the oven to 150° C/130° C fan/gas mark 2.

Mix together the oats, nuts, desiccated coconut and seeds in a bowl.

Combine the honey, oil, water, vanilla, cinnamon and salt in a separate bowl, then pour over the oat mixture and mix well.

Line a baking tray with parchment paper. Spread out the granola mixture on the tray and bake in the oven for 30–40 minutes, stirring occasionally until evenly browned.

Allow to cool before breaking it into pieces. The granola can be stored in an airtight container for up to a month.

200g jumbo oats

75g flaked almonds

75g pecans, roughly chopped

25g desiccated coconut

25g pumpkin or sunflower seeds

60ml runny honey or maple syrup

60ml rapeseed oil

2 tbsp water

1 tsp vanilla extract

1 tsp ground cinnamon

¼ tsp salt

To serve: milk or plain yogurt and fresh fruit

This is a delicious batch-cook win.

GF (if using GF oats) VEGAN (if using maple syrup and vegan milk or yogurt)

Avocado toast with poached egg

PREP TIME: 5 MINS

COOKING TIME: 5 MINS

SERVES: 1

Bring a pan of water to the boil. Turn down to a gentle heat and add the vinegar.

Crack an egg into a cup, then gently slip it into the water. Cook for 3–4 minutes, depending on the size of your egg, until the white is just set. While the egg is cooking, toast the bread.

In a small bowl mash the avocado with a little salt and a squeeze of lemon juice.

Spread the avocado mix over the toast.

When the egg is cooked use a slotted spoon to lift it out of the water. Place on top of the avocado toast. Scatter over freshly ground black pepper and chilli flakes and serve with cherry tomatoes.

1 tbsp white vinegar

1 egg

1 slice of wholegrain or sourdough bread

½ avocado

Sea-salt flakes

A squeeze of lemon juice

Freshly ground black pepper

A pinch of chilli flakes

A handful of cherry tomatoes, halved

My take on a classic.

/ DF GF (if using GF bread) V

Rainbow vegetable frittata

PREP TIME: 5 MINS

COOKING TIME: 10 MINS

SERVES: 1

Preheat the grill to medium.

Heat the oil in a non-stick ovenproof frying pan over a medium heat and add the onion and peppers. Cook for 3 minutes until softened, then add the mushrooms and cook for a further 2 minutes.

Beat the eggs in a small bowl, then season with the salt and black pepper and stir in the parsley.

Pour over the vegetables, gently tilting the pan to make sure the egg mix is evenly spread out. Cook over a low-medium heat for 2–3 minutes until the frittata is almost set. Pop under the grill for 1–2 minutes until the top is golden.

2 tsp olive oil

½ small onion, diced

½ yellow pepper, deseeded and sliced

½ red pepper, deseeded and sliced

6 button mushrooms, sliced

2 eggs

Salt and freshly ground black pepper

1 tbsp chopped fresh parsley

I will happily eat this for breakfast, lunch or dinner.

DF GF V

Green breakfast smoothie

PREP TIME: 5 MINS

SERVES: 1

Place all the ingredients in a blender and whizz until smooth.

250ml coconut or almond milk

A large handful of fresh spinach

75g blueberries (fresh or frozen)

1 small ripe banana

1 tbsp ground flaxseed

A few ice cubes

This is proof that green smoothies taste better than they look!

/ GF VEGAN

Light Meals

Spiced lentil soup

PREP TIME: 10 MINS

COOKING TIME: 30 MINS

SERVES: 2

Heat the olive oil in a large saucepan over a medium heat and fry the onion, garlic, carrot and celery for about 5 minutes or until the vegetables have softened.

Add the lentils, harissa and stock and bring to the boil. Reduce the heat and simmer, partially covered, for a further 25 minutes until the vegetables and lentils are tender.

Finally add the lemon juice, and stir in the fresh coriander and yogurt.

1 tbsp olive oil

1 small onion, finely chopped

1 garlic clove, crushed

1 carrot, diced

1 celery stalk, sliced

100g raw brown or puy lentils

2 tsp harissa paste

1l vegetable stock

Juice of ½ lemon

A handful of fresh coriander, chopped

1 tbsp low-fat yogurt

Lentils are a bit of a new discovery of mine, but I've grown to love them.

/ GF (but check harissa brand) VEGAN (if using vegan yogurt)

Prawn, pak choi and rice noodle soup

PREP TIME: 5 MINS

COOKING TIME: 7 MINS

SERVES: 2

Heat the oil in a large pan over low-medium heat.

Add the ginger, garlic and chilli, and stir-fry for 1 minute or until fragrant.

Add the vegetable stock and noodles. Bring to the boil, then reduce the heat and simmer for 3 minutes.

Add the pak choi, mushrooms, mangetout, soy sauce and prawns, and cook for a further 2–3 minutes until the prawns have turned pink and the pak choi has wilted.

Divide the soup between two bowls and top with the spring onions and sriracha sauce to taste.

This is packed with flavour and light yet filling.

1 tbsp groundnut oil (olive oil works OK too)

1cm fresh ginger, peeled and grated

1 garlic clove, crushed

½ small red chilli, deseeded and finely chopped

500ml vegetable stock (or 1 tsp vegetable bouillon powder dissolved in hot water)

100g thin rice noodles

2 heads of baby pak choi, with the bulbs sliced

50g mixed mushrooms, sliced

75g mangetout

2 tbsp light soy sauce or tamari

125g raw prawns

2 spring onions, sliced on the diagonal

sriracha sauce, to taste (optional)

/DF GF

Sweet potato and butternut squash salad with goat's cheese

PREP TIME: 15 MINS

COOKING TIME: 30 MINS

SERVES: 2

Preheat the oven to 200 °C/180 °C fan/gas mark 6.

Place the butternut squash and sweet potato on a baking tray. Drizzle with the olive oil and scatter over the garlic and a pinch of salt. Toss until the vegetables are coated in the oil, then roast in the oven for about 30 minutes until the vegetables are golden.

To make the dressing mix the tahini, lemon juice and oil with a crack of salt and pepper.

Arrange the salad leaves, beetroot and avocado on a plate. Pile the cooked vegetables on top and scatter with pomegranate seeds and crumbled goat's cheese, before pouring over the dressing.

150g butternut squash, peeled and cubed

1 small sweet potato, peeled and cubed

1 tbsp olive oil

1 garlic clove, crushed

Sea salt

Salad leaves

1 cooked beetroot, sliced

1 avocado

1 tbsp pomegranate seeds

50g goat's cheese

For the dressing:

1 tsp tahini

1 tsp lemon juice

1 tbsp oil

Salt and freshly ground black pepper

This is about as far from a boring salad as you can get.

GF V /

Salmon, spinach and quinoa salad

PREP TIME: 10 MINS

COOKING TIME: 6 MINS

SERVES: 1

Squeeze lemon juice over the salmon fillet. Season with salt and black pepper, then brush with the oil.

Heat a large frying pan over a high heat. Fry the salmon for 2 minutes, then flip over and cook for another 3–4 minutes or until just cooked through. Allow to cool, then flake the fish.

Place the cooked quinoa in a small bowl with the spring onions and red pepper.

Place the dressing ingredients in a small glass bottle or a screw-top jar and shake together thoroughly.

Place the spinach leaves and quinoa mixture in a bowl, pour the dressing over and toss to combine. Then top it with the flaked salmon.

A squeeze of lemon juice

1 small salmon fillet, skinned

Salt and freshly ground black pepper

1 tsp olive oil

125g cooked quinoa

2 spring onions, chopped

½ red pepper, deseeded and sliced

50g baby spinach

For the dressing:

1 tbsp extra virgin olive oil

2 tsp lime or lemon juice

½ tsp wholegrain mustard

Salmon is one of my main go-tos. I never get bored of it.

/ DF GF

Chicken rice bowl with roasted vegetables

PREP TIME: 15 MINS

COOKING TIME: 40 MINS

SERVES: 2

Preheat the oven to 200° C/180° C fan/gas mark 6.

Place the prepared vegetables in a roasting tin with the salt, pepper, thyme and garlic. Drizzle over half the oil and toss lightly so that the vegetables are well coated. Roast in the oven for 25–30 minutes until the vegetables are slightly charred on the outside and tender in the middle.

In a frying pan over a medium heat add the remaining oil and brown the chicken for 8–10 minutes until cooked through. Season with the cumin, paprika and extra salt and pepper if you wish.

To assemble the rice bowls, divide the rice between two bowls, then arrange the vegetables, chicken and hummus in each.

2 courgettes, thickly sliced/ grated

1 red onion, roughly sliced

¼ butternut squash, peeled and diced

Salt and freshly ground black pepper

½ tsp dried thyme

1 garlic clove, crushed

2 tbsp olive oil

2 chicken breasts, diced

1 tsp cumin

1 tsp paprika

250g cooked basmati rice

2 tbsp hummus

This dish is perfectly balanced and comes together in minutes.

DF GF (but check hummus brand)

Mushroom, spinach and red pepper omelette

PREP TIME: 5 MINS

COOKING TIME: 5 MINS

SERVES: 1

Heat the oil in a small non-stick frying pan over a medium heat. Add the mushrooms and pepper and fry for 2–3 minutes until softened. Remove from the pan and place in a bowl.

Beat the eggs in a small bowl with salt and pepper. Place the pan back on the heat, pour in the beaten eggs and tip the pan around so the egg covers the bottom. As the egg cooks lift the edges with a spatula so the uncooked egg runs underneath.

When the egg has just set spoon the mushrooms, pepper and baby spinach over one half of the omelette. Fold the other half of the omelette over to cover the vegetables. Leave to cook for a minute more, then slide the omelette on to a plate.

1 tsp olive oil

A handful of button mushrooms, halved

½ red pepper, deseeded and sliced

2 eggs

Salt and freshly ground black pepper

A handful of baby spinach

This works brilliantly as a quick meal when I'm in a rush.

/ DF GF V

Black bean and avocado burrito

PREP TIME: 15 MINS

COOKING TIME: 10 MINS

SERVES: 1

In a bowl mix together the shallot, beans, quinoa, cumin, paprika, lemon juice, red pepper and olive oil.

Warm the tortilla in the microwave for a few seconds. Spread the bean mixture down the middle, and top with the avocado slices, tomato, rocket and Cheddar. Fold one side of the tortilla over the filling and then fold the outer two edges in before rolling up.

1 shallot, finely diced

75g tinned black beans

75g cooked quinoa

¼ tsp ground cumin

¼ tsp sweet paprika

2 tsp lemon or lime juice

¼ red pepper, deseeded and diced

1 tsp olive oil

1 wholemeal tortilla

¼ avocado, stoned, peeled and sliced

1 tomato, chopped

A handful of rocket

25g Cheddar, grated

This is one of those dishes that is super-easy to put together, but looks really impressive.

V/

Salmon sushi bowl

PREP TIME: LESS THAN 10 MINS (20 MINS IF USING UNCOOKED RICE)

SERVES: 1

Cook the rice according to the packet instructions. Drain, then stir through the rice wine vinegar.

Make the dressing by whisking all the ingredients together.

Place the spinach in a bowl. Top with the rice, salmon and edamame beans. Fan out the avocado slices and scatter over the spring onions and sesame seeds. Drizzle over the dressing.

50g brown rice (or 100g cooked)

2 tsp rice wine vinegar

A handful of baby spinach

75g smoked salmon

50g frozen edamame beans, defrosted

½ avocado, sliced

1 spring onion, finely chopped

2 tsp black sesame seeds

For the dressing:

1 tsp sesame oil

1 tsp soy sauce or tamari

2 tsp honey

A pinch of chilli flakes

A squeeze of lime juice

The pefect dish if you're in need of something quick and light.

/ DF GF (if using tamari)

Main Meals

Thai green chicken curry

PREP TIME: 15 MINS

COOKING TIME: 20 MINS

SERVES: 2

Heat the oil in a large frying pan over a medium heat and fry the onion for a few minutes until softened.

Add the curry paste, stir and cook for a minute until fragrant.

Add the chicken and stir until coated in curry paste and lightly browned on all sides, about 2 minutes.

Add the coconut milk and stock, then bring to the boil and turn down the heat. Continue cooking for 10 minutes.

Add the vegetables and cook for a further 5 minutes.

Season with salt, pepper and lime juice, and stir in the fresh coriander.

Serve with cooked Thai rice or rice noodles.

1 tbsp vegetable oil

1 small onion, chopped

2 tbsp Thai green curry paste, or to taste

200g chicken breast fillet, cut into strips

200ml tinned coconut milk

125ml chicken stock or water

125g asparagus spears, cut into 5cm lengths

125g baby corn cut in half lengthways

125g green beans, cut into 5cm lengths

Salt and freshly ground black pepper

A squeeze of lime juice

A handful of fresh coriander, chopped

To serve: Thai rice or rice noodles

Meet your new Saturday-night staple.

/DF GF (but check curry paste)

Pasta with prawns, tomatoes and courgettes

PREP TIME: 15 MINS

COOKING TIME: 25 MINS

SERVES: 2

Heat half the olive oil in a non-stick frying pan over a medium heat.

Fry the onion for 3 minutes, then add the garlic and courgette. Cook for 5 minutes, then add the chopped and cherry tomatoes and thyme and simmer for 8–10 minutes.

Meanwhile cook the pasta in boiling water according to the packet instructions. Drain and mix with the tomato mixture.

Return the pan to a medium heat and add the remaining oil. When hot add the prawns, then season and fry, stirring for 2–3 minutes until they're pink and cooked through.

Put the pasta in a bowl, arrange the prawns on top, and scatter over the basil and Parmesan, if using.

1 tbsp olive oil

½ small onion, diced

1 garlic clove, sliced

1 courgette, sliced

200g tinned chopped tomatoes

125g cherry tomatoes, halved

¼ tsp dried thyme

150g pasta

12 large raw king prawns

Salt and freshly ground black pepper

A few basil leaves

To serve: Parmesan (optional)

This is a great dish to cook for the whole family.

/DF (without Parmesan) GF (if using GF pasta)

Tofu and bean burgers with red cabbage and apple slaw

PREP TIME: 25 MINS

COOKING TIME: 15 MINS

SERVES: 2

Preheat the grill to medium.

Put the tofu, curry paste, onion, coriander and seasoning into a food processor. Process until combined but not smooth. Add the beans and pulse briefly until they are roughly broken up. Add the breadcrumbs, then shape the mixture into four burgers.

Place on a non-stick baking tray, brushing with oil and grill for 10–12 minutes, turning once, until golden on top and piping hot.

Meanwhile place all the ingredients for the slaw in a large bowl and mix together.

Warm the flatbreads. Place the burgers with the slaw on the flatbreads, fold over and serve.

These are bursting with flavour and so satisfying.

100g firm tofu

2 tsp mild curry paste

½ small red onion, roughly chopped

A small handful of fresh coriander, roughly chopped

Salt and freshly ground black pepper

200g tinned red kidney beans, drained

25g fresh wholemeal breadcrumbs

Olive oil for brushing

2 small flatbreads

For the slaw:

½ small red onion

150g red cabbage, finely shredded

2 spring onions, finely chopped

1 Granny Smith apple, grated

1 tsp apple cider vinegar

2 tsp apple juice

½ tsp Dijon mustard

VEGAN (but check mustard brand)

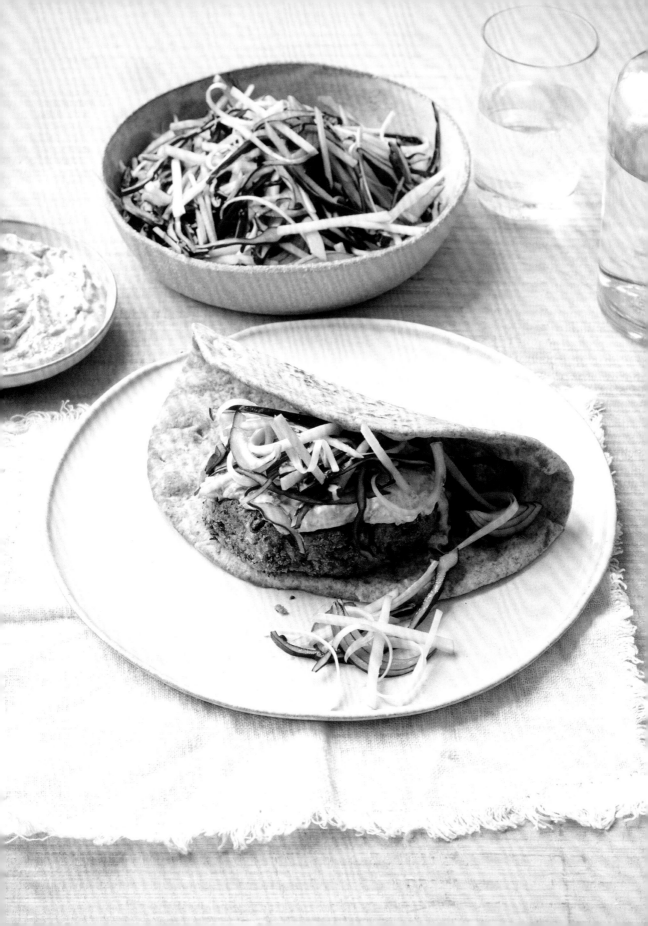

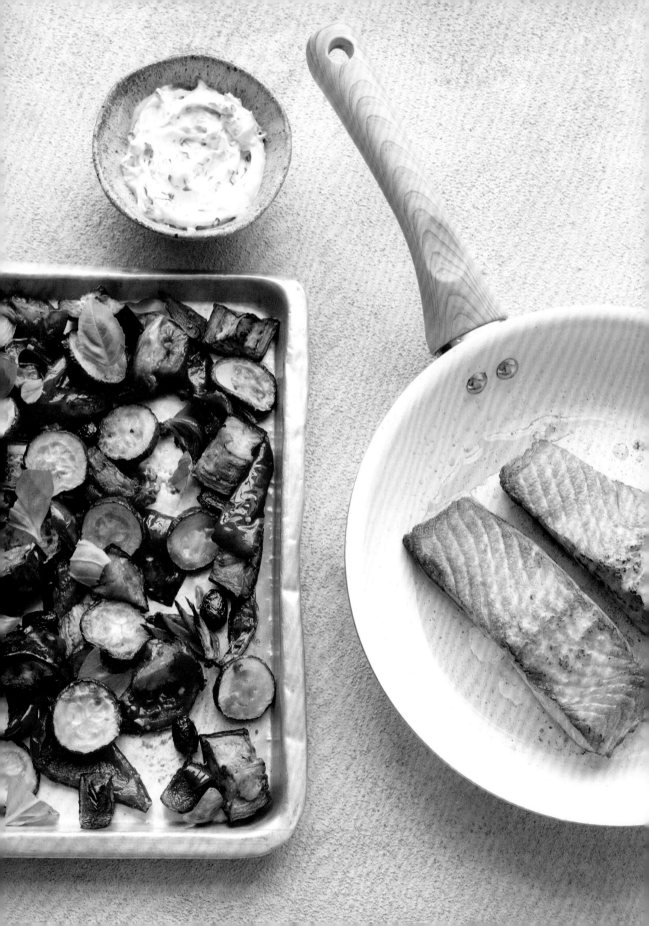

Pan-fried salmon with roasted Mediterranean vegetables

PREP TIME: 15 MINS

COOKING TIME: 40 MINS

SERVES: 2

Preheat the oven to 200° C/180° C fan/gas mark 6.

Place the prepared vegetables, garlic and olives in a large roasting tin. Drizzle over half the olive oil and toss lightly so that the vegetables are well coated. Roast in the oven for 25–30 minutes until the vegetables are charred on the outside and tender in the middle.

Meanwhile heat the remaining oil over a medium heat in a non-stick pan. Season the salmon, then add to the pan skin side down for 4–5 minutes. Turn over, then fry for a further 4–5 minutes until golden and just cooked.

Arrange the salmon on top of the vegetables, then squeeze the lemon over the top and sprinkle with basil. Serve with crusty bread if you like.

½ aubergine, cut into 1cm cubes

½ red onion, cut into wedges

1 red pepper, deseeded and cut into quarters

1 courgette, cut into thick slices

2 tomatoes, cut into quarters

2 garlic cloves, finely chopped

About 10 pitted black olives

2 tbsp olive oil

2 salmon fillets, skinned

Salt and freshly ground black pepper

Lemon juice

A handful of fresh basil, roughly torn

Crusty bread (optional)

You can seriously never have enough salmon (or vegetables!).

/DF GF (without bread)

Chicken tagine

PREP TIME: 15 MINS

COOKING TIME: 40 MINS

SERVES: 2

Heat the oil in a large pan over a medium heat, add the onion and fry for 2 minutes until softened.

Add the ginger, paprika and ground coriander and cook for a further minute.

Add the chicken and fry until browned, about 5 minutes.

Add the stock, tomatoes, chickpeas and dried apricots.

Bring the mixture up to the boil, then turn down the heat and simmer for 30 minutes or until the chicken is tender.

Add the spinach and cook for a further minute until just wilted.

Season with salt and freshly ground black pepper, then stir in the coriander.

Serve with couscous.

1 tbsp olive oil

1 small onion, finely chopped

1 tsp grated fresh ginger

1 tsp paprika

1 tsp ground coriander

4 skinless, boneless chicken thighs, cut in half

250ml chicken stock (or ½ stock cube dissolved in 250ml boiling water)

200g tinned chopped tomatoes

200g tinned chickpeas, drained and rinsed

40g dried apricots, roughly chopped

50g fresh spinach

Salt and freshly ground black pepper

A handful of fresh coriander, roughly chopped

To serve: couscous, cooked

This ticks every nutritional box for me.

DF GF (without couscous)

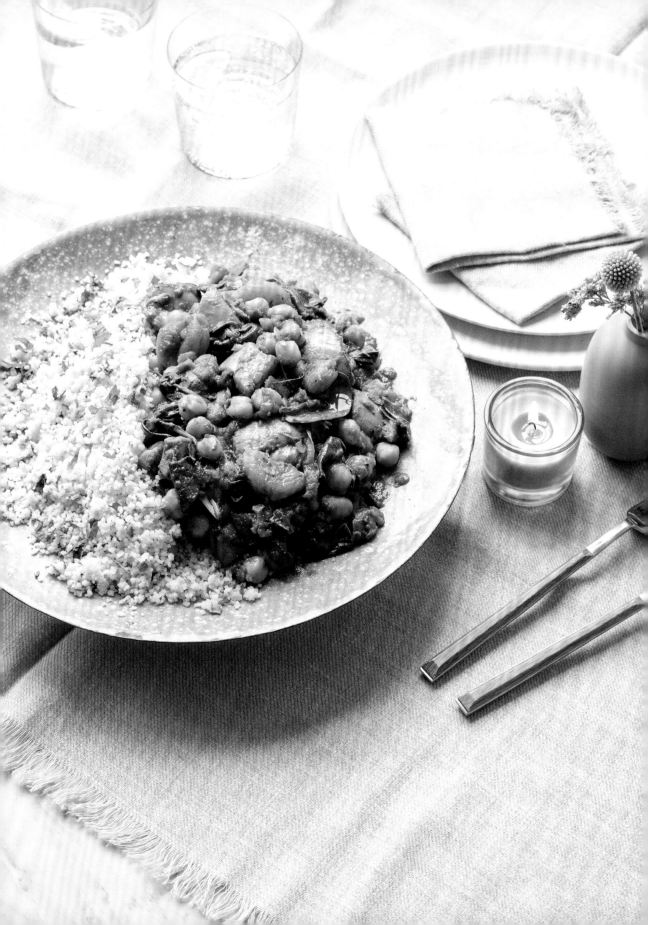

Red pepper and feta tortilla pizza

PREP TIME: 10 MINS

COOKING TIME: 10 MINS

SERVES: 1

Preheat the oven to 220° C/200° C fan/gas mark 7.

Place the tortilla on a baking tray.

Season the passata/tomatoes with salt and pepper, then spread over the tortilla, scatter over the chilli flakes if using and arrange the pepper, feta, cherry tomatoes and olives on top.

Bake for 5–7 minutes or until the tortilla is crisp and golden brown round the edges.

Remove from the oven, slide on to a plate and top with the rocket.

1 wholewheat tortilla

100g passata or tinned chopped tomatoes

Salt and freshly ground black pepper

A sprinkling of chilli flakes (optional)

½ red pepper, deseeded and thinly sliced

25g feta, coarsely crumbled

A few cherry tomatoes

A few black olives

A handful of rocket

Who says you can't eat pizzas and still be healthy?

V /

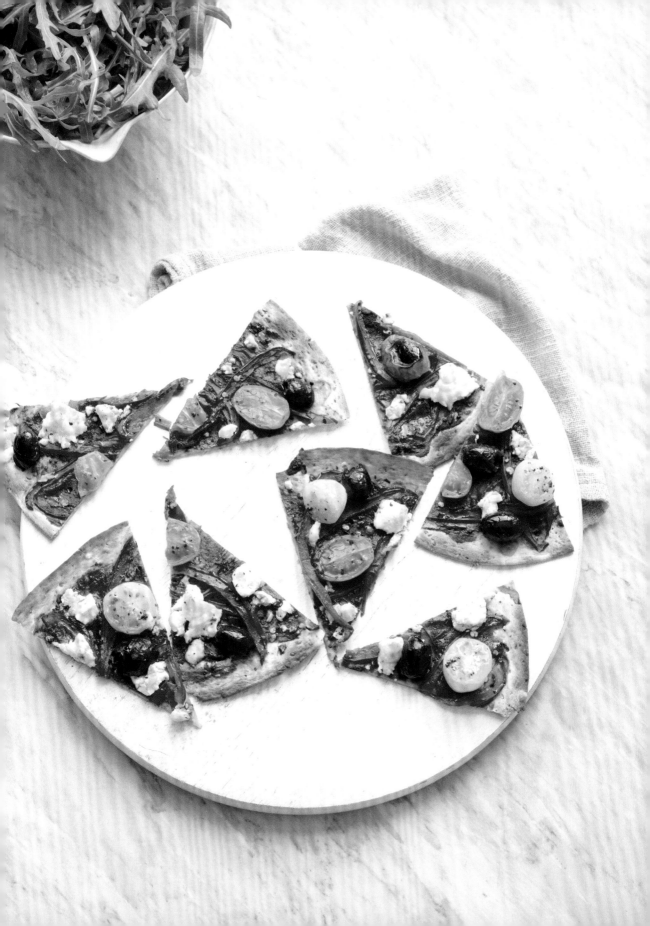

Red lentil and coconut curry

PREP TIME: 20 MINS

COOKING TIME: 30 MINS

SERVES: 2

Heat the oil in a pan over a medium heat, then add the onion and pepper, and fry for 3–4 minutes until softened.

Add the garlic, ginger, chilli and spices, and continue cooking for a further minute, stirring continuously.

Add the lentils and coconut milk, then bring to the boil, cover and simmer for about 20 minutes, adding the stock gradually to prevent it from drying out. Add the mange-tout, peas and kale for the final five minutes of cooking.

Stir in the cashew nuts and lemon juice and season with salt and freshly ground black pepper.

Finally stir in the fresh coriander.

A great meal to serve if you're having mates over for dinner.

1 tbsp rapeseed or coconut oil

1 small onion, finely chopped

½ red pepper, deseeded and thinly sliced

1 garlic clove, crushed

1cm piece fresh ginger, peeled and finely grated

½ green chilli, finely sliced, or to taste

1 tsp each ground cumin, ground coriander and turmeric

100g red lentils

400ml tinned light coconut milk

300ml stock

100g mangetout

75g frozen peas

100g kale with hard stems removed

A handful of cashews

Juice of ½ lemon

Salt and freshly ground black pepper

A small bunch of fresh coriander, chopped

/ GF VEGAN

Chicken noodle stir-fry

PREP TIME: 15 MINS

COOKING TIME: 10 MINS

SERVES: 1

Cook the noodles according to the packet instructions. Drain and put aside while you make the stir-fry.

Heat the oil in a wok or frying pan over a medium heat.

Add the spring onions, ginger, garlic and chicken, and stir-fry until the chicken is browned all over.

Add the vegetables to the pan and continue cooking until just cooked, about 3 minutes.

Stir in the sriracha sauce, soy sauce and noodles, and continue to cook over a low heat for 1–2 minutes, or until heated through.

Transfer into a bowl and sprinkle over the sesame seeds.

50g wholewheat or buckwheat noodles

2 tsp sesame oil

4 spring onions, sliced into large pieces

1cm piece fresh ginger, peeled and finely grated

1 garlic clove, crushed

1 skinless, boneless chicken thigh fillet, thinly sliced

½ red pepper, deseeded and thinly sliced

50g tenderstem broccoli or broccoli florets

1 small courgette, sliced into 2.5cm pieces

2 tsp sriracha sauce, or to taste

1 tbsp soy sauce or tamari

1 tbsp sesame seeds, toasted

Stir-fries are so quick and easy, and this one is packed with nutrients.

DF GF (if using buckwheat noodles and tamari)

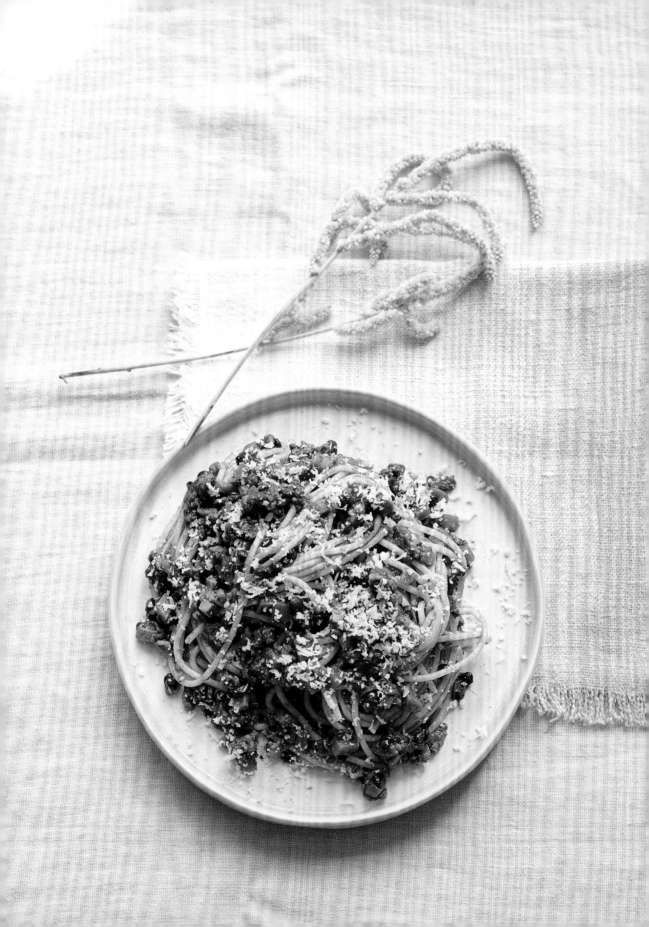

Beef and lentil Bolognese

PREP TIME: 15 MINS

COOKING TIME: 40 MINS

SERVES: 2

A delicious winter warmer that packs a solid protein punch.

Heat the oil in a large pan over a medium-high heat.

Add the mince, onion and garlic. Cook, stirring with a wooden spoon to break up the mince, for 5–6 minutes or until browned.

Add the celery, mushrooms and carrot. Cook for 5 minutes or until the vegetables are softened.

Add the tinned tomatoes, half of the water, tomato puree, oregano and Worcestershire sauce. Reduce the heat, half cover the pan and simmer for 15 minutes.

Meanwhile cook the spaghetti in boiling water according to the packet instructions. Drain.

Add the lentils to the sauce for the last five minutes of cooking. Add the rest of the water if it looks too thick.

Season with salt and freshly ground black pepper, then mix the sauce into the spaghetti and serve with grated Parmesan if you like.

1 tbsp olive oil

250g lean beef mince

1 small onion, finely chopped

1–2 garlic cloves, crushed

1 stick celery, chopped

75g mushrooms, chopped

1 carrot, diced

400g tinned chopped tomatoes

200ml water

1 tbsp tomato puree

1 tsp dried oregano

2 tsp Worcestershire sauce

150g spaghetti

125g cooked puy lentils

Salt and freshly ground black pepper

To serve: Parmesan cheese (optional)

/ DF (without Parmesan)

Three-bean chilli

PREP TIME: 15 MINS

COOKING TIME: 15 MINS

SERVES: 2–3

Heat the oil in a large non-stick pan over a medium heat.

Add the onion, celery and red pepper, and fry for 5 minutes until softened.

Add the garlic, chilli, paprika, oregano, cumin and ground coriander, and cook for a further minute.

Add the tomatoes, tomato puree and beans and bring to the boil.

Reduce the heat and simmer for 10 minutes until the sauce has thickened, adding the water gradually if it is too dry.

Season with salt and freshly ground pepper, then stir in the parsley.

Serve with rice or baked sweet potato.

This amazing chilli will help to fire up your metabolism.

1 tbsp light olive or rapeseed oil

1 small onion, finely chopped

1 stick celery, chopped

½ red pepper, deseeded and diced

1–2 garlic cloves, crushed

1 tsp chilli powder, or to taste

1 tsp smoked paprika

½ tsp each dried oregano, ground cumin and ground coriander

400g tinned chopped tomatoes

1 tbsp tomato puree

200g each tinned red kidney beans, cannellini and borlotti beans, drained and rinsed

100ml hot water

Salt and freshly ground black pepper

A handful of fresh parsley, chopped

To serve: rice or baked sweet potatoes

GF VEGAN /

Snacks

Hummus with crudités

PREP TIME: LESS THAN 10 MINS

SERVES: 2

Put all the hummus ingredients in a food processor or blender and blend until smooth.

Taste to check the seasoning. Add a little extra water if you want a thinner texture.

Spoon into a shallow dish and scatter over the pine nuts. Serve with the crudités.

I promise you this hummus tastes better than any shop-bought version.

400g tinned chickpeas, drained and rinsed

1 garlic clove, crushed

2 tbsp extra virgin olive oil

2 tbsp tahini

Juice of ½ lemon

5 tbsp water

1 tbsp pine nuts, toasted

Salt and freshly ground black pepper

Crudités: carrot sticks, cucumber sticks, celery sticks and strips of red, yellow and green peppers

/ GF VEGAN

Guacamole with tortilla crisps

PREP TIME: 15 MINS

COOKING TIME: 10 MINS

Preheat the oven to 200° C/180° C fan/gas 6.

Halve the avocado and spoon out the flesh into a bowl. Mash with the lime juice.

Stir through the red onion, chilli, tomato, coriander and seasoning.

For the crisps, cut the tortillas into triangles and arrange in a single layer on a baking tray.

Drizzle over a little olive oil, scatter over the chilli flakes, and pop in the oven for 5–6 minutes until golden and crisp.

1 large ripe avocado

1 tbsp lime juice

½ red onion, finely chopped

¼ small red chilli, deseeded and finely chopped

1 tomato, finely chopped and without seeds

1 tbsp fresh coriander, finely chopped

Salt and freshly ground black pepper

For the crisps:

1 soft wholewheat tortilla

Olive oil

A pinch of chilli flakes

Bring a bit of Mexican flavour to your healthy snacking.

VEGAN

Crispy chickpeas

PREP TIME: 2 MINS

COOKING TIME: 25 MINS

SERVES: 4

Preheat the oven to 190° C/170° C fan/gas mark 3.

Put the chickpeas in a bowl and toss with the olive oil, curry powder and salt, ensuring the chickpeas are well coated.

Spread them out on a baking tray and roast for 20–25 minutes, stirring every 10 minutes, until the chickpeas are golden and crispy.

Allow to cool and store in an airtight container for up to three days.

400g tin chickpeas, drained and rinsed

1 tbsp olive oil

2 tsp curry powder

A pinch of sea salt

These are great to pop into a small container and snack on while you're out and about.

/ GF VEGAN

Granola bars

PREP TIME: 15 MINS

COOKING TIME: 25 MINS

MAKES: 10

Preheat the oven to 200° C / 180° C fan / gas mark 6 and line an 18cm-square tin with baking paper.

Put the honey, nut butter and butter or coconut oil in a small saucepan over a low heat and warm until melted.

In a large bowl or food mixer mix together the almonds, seeds, oats and dried fruit.

Stir in the honey mixture and mix until well combined.

Press evenly and firmly into the baking tin and bake for approximately 25 minutes until light golden.

Leave to cool before slicing into bars.

100ml honey or maple syrup

150g nut butter (e.g. peanut, almond or hazelnut)

50g butter or coconut oil

75g almonds, lightly toasted and coarsely chopped

75g mixed seeds (e.g. pumpkin, sunflower and sesame seeds)

150g rolled oats

100g dried fruit (e.g. raisins, cranberries or dates)

A great guilt-free way to satisfy your sweet tooth.

GF (if using GF oats) VEGAN (if using maple syrup and coconut oil)

Protein balls

PREP TIME: 20 MINS

MAKES: 16

Place all the ingredients in a food processor and blitz until a stiff 'dough' forms, adding some water to the mixture if needed.

Roll into 16 balls. Put the extra desiccated coconut on a plate, then roll each ball in coconut or flaked almonds or nuts if you prefer.

Keep in an airtight container and store in the fridge for up to a week.

2 tbsp almond butter

175g ready-to-eat soft dates or Medjool dates

1 scoop (25g) chocolate protein powder

50g desiccated coconut, plus extra for rolling

1 tbsp cacao or cocoa powder

1 tbsp water to combine (if needed)

The perfect after-gym pick-me-up.

/ GF VEGAN

Mini frittata muffins

PREP TIME: 15 MINS

COOKING TIME: 20 MINS

MAKES: 12

Preheat the oven to 180° C/160° C fan/gas mark 4. Grease a 12-hole muffin tin or line with paper cases and spray with oil.

Crack the eggs into a large bowl and whisk together.

Add the spring onions, courgette, red pepper, spinach, Cheddar and chilli flakes. Season with salt and pepper and stir to combine.

Spoon the mixture into the muffin tin and bake in the oven for 15–20 minutes until they are firm to the touch and lightly golden on top.

Allow to cool in the tin for a few minutes before removing.

12 eggs

4 spring onions, finely sliced

½ courgette, grated

½ red pepper, deseeded and diced

A handful of baby spinach

75g Cheddar, grated

A pinch of chilli flakes

Salt and freshly ground black pepper

So good you have to share them out (or not!).

GF V /

Chapter 3
BODY

Exercise makes me so happy

'GOOD MORNING. THE GYM IS WAITING FOR YOU.'

I love exercising. I know I'm lucky to enjoy it because not everyone does, but it makes me feel good, look better and it helps with my mental health. I don't just exercise to stay in shape; I do it because it has a knock-on effect on everything.

The only constant I've ever had with my health and fitness is going to the gym. My eating habits and relationship with food may have been all over the place at times in my teens and early twenties, but I didn't ever stop exercising.

I may love exercise but I will never be one of those people who is in the gym for several hours a day. My exercise routine has to fit in with my life. I try to work out at least four times a week doing cardio and abs, often with a personal trainer, and I also go for a walk at least once a day.

I find that walking is great for keeping weight off. I've got a little dog, a Chihuahua called Ronnie, and when I'm out walking with him I feel like I've got total freedom. It's just me and him and we love each other's company (well, I hope he loves mine!).

If for any reason I can't get to the gym, walking is my go-to. It clears my mind, and if I'm having a stressful day it can redress the balance for me. If I feel sluggish or I'm overthinking things, a walk will refocus my mind and give me more energy. It's like hitting refresh.

The lovely thing about dog walking is how many people you meet. You could walk for miles on your own and not chat to anyone, but the minute you've got a dog with you everyone becomes your friend.

Motivation is key

*'IF YOU CAN'T STOP THINKING ABOUT IT,
DON'T STOP WORKING FOR IT.'*

I definitely have those mornings where I wake up and I think 'I can't be bothered to exercise today'. But I'm up with the kids at 6 a.m. anyway, and once I'm up I may as well work out. If I get up, put on my gym clothes and go, it's done. If I tell myself I'll do it later, I never do.

If I'm really, really tired and not in the mood to work out, I won't, because I know I won't put everything into it and I'll annoy myself. Luckily that only happens once in a blue moon.

Generally I can always find a way to motivate myself. I always know I'll feel better afterwards so I'll think ahead and imagine how much better I'll be once I've got a workout in the bag.

If I'm having a lazy week, I'll book a class with a friend so there's no getting out of it. That way, not only would I be letting myself down, but I'd be letting my mate down too.

The only time I let myself off is when I'm ill because sometimes your body is telling you it needs a break. If you keep trying to battle on, you won't be doing a good workout anyway, and it will probably take you twice as long to recover.

Getting in shape is definitely about your mind as well as what you eat and going to the gym. If your head isn't in the right place, it's so hard to get yourself into the zone where you want to exercise and eat right.

We all have those little lapses, whether they last a day or a week, and the most important thing is that you don't let them last any longer. Once you go past a certain point you almost start to feel like you're never going to get it back. It's about taking that first step and making a start again. I may not want to go back to the gym, but I know I'll feel worse if I don't. My golden rules are to try to never miss a Monday workout and to never go more than three days without exercise.

I plan my workouts at the beginning of the week, and once they're in my diary they're staying there. It's easy to cancel workout sessions if something else crops up, and quite often they're the first thing people will sacrifice. I try to make sure they're the last thing. They're not an indulgence for me; they're an essential.

Once I have those sessions booked I can work other things around them. If they're not in my diary, I can't focus. My workouts form the frame of my week.

I listen to a lot of grime to stay focused in the gym, and that really gets me hyped up. If my trainer says to me we've got to do one more circuit and I'm dead on my feet, I'll put on some Stormzy and it will give me that extra kick I need to do the final round of exercise. And I'll do it well.

Music is great, but watching TV when I'm working out is a hundred per cent no-no. I've got to focus. I've only got an hour to work out so I want to do that well, and TV is a terrible distraction. I see people walking on a treadmill watching Netflix and they don't even break a sweat. There's no point in being in a gym if you're so distracted you don't make an effort.

I do often try to work out for around an hour if I can, but I don't always have the time. If that's the case I'll ramp things up and do an intensive twenty-minute HIIT session.

Pick a good
workout partner

'BECOME MORE AWARE OF WHAT'S REALLY WORTH YOUR ENERGY.'

I find it really helpful working out with someone, so I think it's good to have a gym buddy, whether it's a partner, a friend or a trainer. I used to work out on my own when I was younger but as I've got older I tend to go with other people a lot more.

If I'm lacking motivation, I'll see if any of my friends are around because if you're together you push each other. It seems to make the time go quicker. But you do need to pick your partner well. You need to make sure they want to work out as much as you do, and that they'll motivate you.

The good thing about working out with another person is that I'm also super-competitive. If I'm training alongside someone, I want to beat them. I want to be better. If they're doing something really well, I'll up my game. If someone tells me I can't do 100 sit-ups, I'll do 110. I always want to do extra.

I like to be good at things and it really frustrates me if I'm not. I won't enjoy an exercise anywhere near as much if I'm not good at it. I'm rubbish at pull-ups and that drives me mad. I really want to master them and I'm trying all the time.

Rio and I are super-competitive with each other, but obviously he's a World Cup-standard athlete, which doesn't go down too well with me. He's got such good genes and he's naturally really strong so I'm never going to outdo him. I find it annoying that he's so much better than me at certain things. He also winds me up about it, so I'll use that to push myself even more.

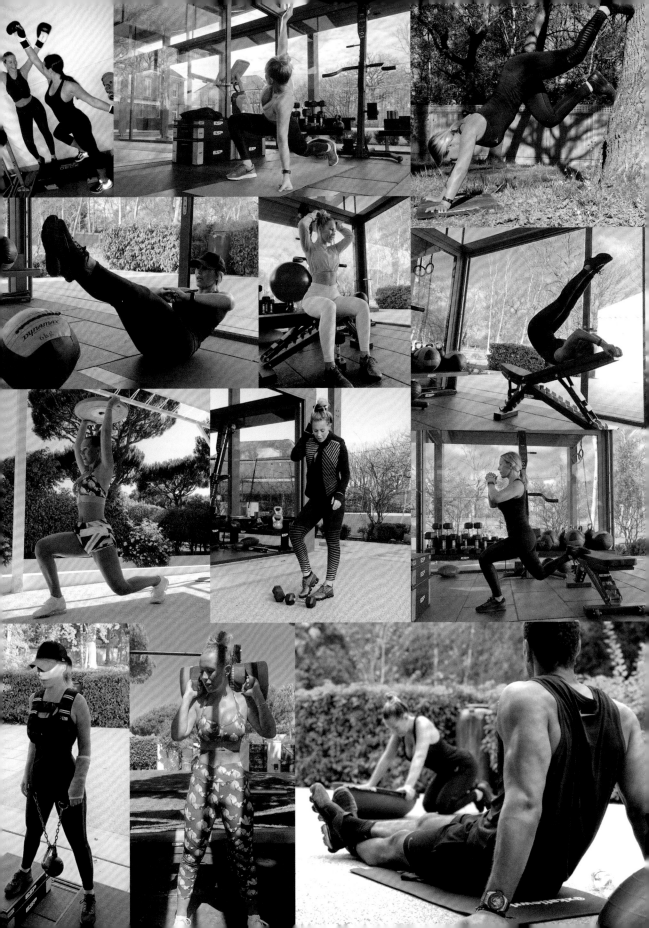

'The good thing about working out with another person is that I'm also super-competitive. If I'm training alongside someone, I want to beat them. I want to be better. If they're doing something really well, I'll up my game.'

Rio and I often do the same things in the gym, but we do different weights, and we are good motivators for each other. We also have a right laugh, and at times I'll get to the end of a really tough workout and it won't have felt tough because I've enjoyed it so much. I love that. Even though he can outdo me with certain things he's still a great gym partner.

I'm very lucky that I have the opportunity to work out regularly with a personal trainer. I learn a lot from them and I've picked up so much information over the years, but having a personal trainer certainly isn't essential. We're all capable of finding our own way and I hope you will learn something here.

Because I've picked up so much information over the past fifteen years, if someone says to me, 'Can you do a workout?' I can do them a really good one off the cuff. When we went away with family last summer I was training with my sister-in-laws and some of my friends every day. I've worked out for so many years I do know what I'm doing. I did glutes and abs with Rio's sisters and they could barely walk the following day. I think it shocked them.

Some people assume I go into the gym and fart-arse around, and when Rio's dad first saw me lifting weights in the gym and working hard he was really taken aback. I think he thought I probably went in, did a bit of stretching and came back out again. I like surprising people.

We're a fit family generally, and Rio, the children and I do a lot of walks and ride bikes, so exercising is really important to us. We like to go on active holidays together, so we'll go away to Center Parcs and the children will play football and badminton and we all join in. We really enjoy being healthy by having fun.

I know my limits, but I still push myself

'YOU ONLY WANT WHAT'S EASY; THAT'S WHY WHAT YOU GET NEVER LASTS . . .'

I know how much I can push myself now and I listen to my body. I didn't use to and I used to be very injury-prone as a result. I've even broken bones in the past, and my nickname is Calamity Kate. I know how much I can do and if I'm really struggling and I know I'm being too tough on myself, I will back down.

I've got two trainers that I alternate and they both push me in different ways. While they are both amazing at what they do, though, they're not inside my body feeling what I'm feeling, and only I truly know my limits.

There is no point killing myself if it means I then won't be able to work out for another week. I like to feel breathless and I like to know I've done a good workout, but I would never try to push myself too hard or lift weights I know are beyond my capabilities because it's counter-productive.

I'm more likely to push myself with HIIT and aerobic-style exercises because they may exhaust me, but they're not going to injure me. Weights, HIIT and circuits are the things I enjoy most. I love ab workouts, and I like feeling the effects the next day because you know you've really worked.

If I'm in a rush in the gym, my go-to is generally a circuit. I don't tend to do big weight sessions on my own because I need someone to spur me on, but I can set up a circuit or a HIIT session easily and I can make myself really go for it. I'll even do that with the kids sometimes, but obviously they'll use lighter weights than me!

I like my workouts to be short and sharp. When I do a circuit I like it to be 40 seconds going full-throttle, and then 20 seconds rest, and then back to it. I don't mind doing any exercises if they're quick, even the body-weight exercises like burpees and squats.

If I can do them for 20, 30 or 40 seconds, brilliant. But any more than that and I want to give up. I'm the same with resting in between exercises. If I rest for a minute, I find it really hard to get started again, so 30 seconds is my maximum. It's best for everything to be as quick as it can be.

I don't get to go to boot camps as much as I'd like due to other commitments. Back in the day I would be flipping tyres and pulling cars along with a group of other people, and it was horrendous. I'll try anything once and I like a challenge, but some of the boot camps I did were hell on earth. I don't feel the need to put myself through that any more. I only went along to them because I thought it was what I should be doing, but now I only do exercises that make me happy. Life is too short to roll around in freezing muddy puddles.

Find out what you enjoy and what works for you. If you find you've got more stamina with HIIT workouts and you know you'll dedicate more time to them, they can be your go-to. If there's something you really hate, do it in moderation.

I've learnt what I do and don't like through trial and error, and finding out has been a game changer, but I try to include a bit of everything and do more of the stuff I love.

Let's get started!

'GIVE YOURSELF SOME CREDIT. YOU'VE COME PRETTY FAR.'

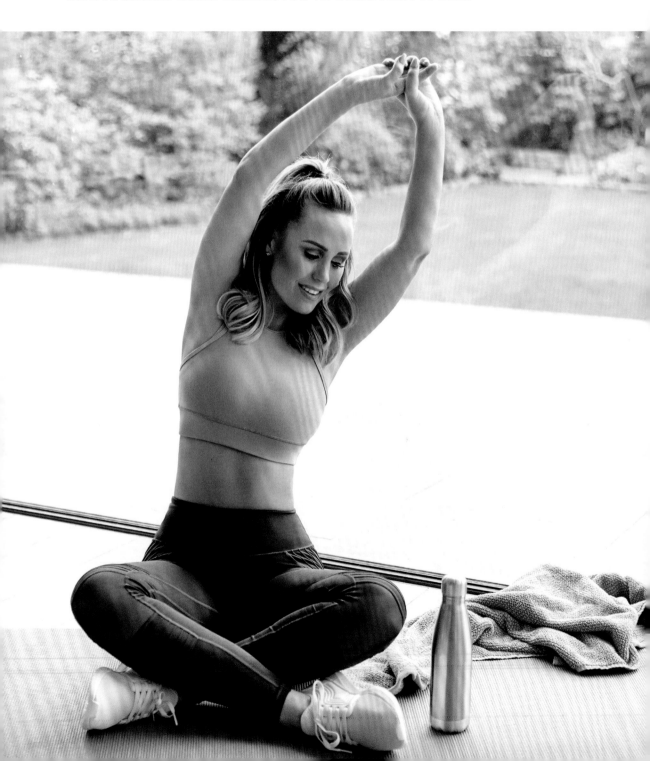

EAT WELL FOR YOUR WORKOUT

How you eat before and after your workout has a huge effect, so here are some tips on how to fit meals around training.

If you're exercising later in the day it's a good idea to leave it at least 1–2 hours after your last meal, especially if you're doing high-intensity activity.

It's important to make sure you have protein with every meal, even more so when you're training, so try to build your meals around it.

It's also better, but not essential, to have your main carbs for the day after you've worked out, as opposed to before. That will help with the way your body uses them, and it will help replenish glycogen, which in turn will help your body recover before your next workout.

If you're training first thing in the morning, you may want to train 'fasted', which basically means on an empty stomach. Some trainers recommend you have a black coffee upon waking, but as I don't drink coffee I like to start with a green tea.

I frequently drink Nocco (a drink containing amino acids and vitamins) before I work out.

PREPARE YOURSELF FOR A PEP TALK!

1 / THE BOTTOM LINE IS THAT NO ONE IS GOING TO DO THIS FOR YOU. No one else can get you a better bum or leaner arms or a flatter stomach. You are in charge of your own body.

2 / YOU WILL GET OUT WHAT YOU PUT INTO THIS PROGRAMME, and I can promise that if you follow it, you will get great results in a short amount of time.

3 / ALL I ASK IS THAT YOU GIVE IT YOUR BEST. The more you push yourself, the better the results, but you have to go at the pace that is right for you. We don't want any injuries that will hold you back.

4 / I HONESTLY DON'T BELIEVE PEOPLE HAVE TO EXERCISE FOR TWO HOURS A DAY IN ORDER TO GET FIT. My workouts are short, but they're effective.

5 / THESE ROUTINES ARE SUITABLE FOR EVERYONE, from long-term exercisers and new mums to those of you who need a bit of encouragement to get back into working out.

6 / I AM GOING TO PUSH YOU SO YOU GET REAL RESULTS. I've structured it so you'll be alternating workouts, meaning you won't be doing crazy cardio seven days in a row and risking burnout.

7 / EVERY WORKOUT IS INTENSE, CHALLENGING, FUN AND SWEATY – ALL THE THINGS I LOVE. It's a real workout plan that will work. There are upper- and lower-body workouts, as well as full-body routines, so every bit of you will be put through its paces.

8 / THE PLAN HAS BEEN CAREFULLY WORKED OUT SO THE WORKOUTS GET PROGRESSIVELY HARDER OVER THE FOUR WEEKS. That way you're not pushing yourself too hard at the beginning, and you'll be in the right frame of mind to give it that bit extra towards the end. You'll be gradually increasing the amount you do each day, as well as the intensity, to allow your body to adjust to your new routine.

9 / DON'T GIVE YOURSELF A HARD TIME IF YOU FIND THINGS TOUGH AT FIRST. It takes a while to get used to a new way of working and develop habits. No one is expecting you to be an expert overnight. If you find an exercise hard, stick at it. Practice makes perfect.

10 / IF YOU HAVE TO MISS A SESSION, DON'T THINK ALL IS LOST! If I can't go to the gym because something happens with one of the kids, I have to get over it and go again as soon as I can. I think that's a much healthier attitude than being obsessive. You need to apply the same attitude to the gym as you do to food – it's all about balance.

11 / DON'T GIVE YOURSELF A HARD TIME OR TELL YOURSELF YOU'RE A FAILURE IF YOU SLIP A BIT. JUST GET BACK ON IT! Exercise should make you feel better about yourself, not worse. Perfection doesn't exist. Doing our best does.

Kit list

You can do all of these workouts at home with the minimum amount of equipment, but ideally you will need:

○ 2–3KG DUMB-BELLS

○ 5–6KG DUMB-BELLS

○ A RESISTANCE BAND

○ A YOGA MAT

You should be able to get all of these items for less than twenty pounds, which is less than one session with a personal trainer!

You'll be able to create your own mini gym with just those few bits of equipment so if you can, and you have the room, make it a nice space for yourself.

It's really helpful to have a mirror so you can make sure you're doing the exercises properly. An old one propped against a wall will do fine.

Your all-important exercise guide

I want you to enjoy using my workout plan. Please remember that the information here is a guide and that you must work at a level that feels comfortable to you. If you have any health concerns, please seek medical advice before beginning a new exercise plan.

For more detailed instructions on how to conduct each exercise, please consult the glossary where you will find step-by-step notes. Using the correct technique reduces your chance of injury and gets better results!

All my workouts are designed to be quick and effective, so even if you're short on time there's no excuse! You will see that some exercises use weights and others use body weight. Body-weight exercises simply mean that you're using your body instead of any kind of equipment. I use a resistance band in some exercises, but if you don't have one just increase the reps so each exercise is still challenging for you.

If you want to ramp up your workout, add dumb-bells where appropriate and add a few more reps where you feel like you can. Results only happen if you're pushing yourself, so don't take the easy option!

Please don't skip the warm-up and cool-down. These are essential if you want to look after your body and ensure it's in a fit state to enable you to exercise and enjoy yourself the following day. Finally, always remember to drink water, give it your all and have fun!

	Week 1	Week 2	Week 3	Week 4
	Reps 10–12	*Reps 12–15*	*Reps 15–20*	*Reps 10–12*
	Lighter weights	*Lighter weights*	*Lighter weights*	*Heavier weights*
MONDAY	Upper body	Upper body	Full-body HIIT	Full-body HIIT
TUESDAY		Full-body HIIT	Upper body	Lower body
WEDNESDAY	Lower body		20–30-min. jog	20–30-min. run
THURSDAY		Lower body	Lower body	Upper body
FRIDAY	Full-body HIIT	Full-body HIIT	Full-body HIIT	Full-body HIIT
SATURDAY				
SUNDAY	30–40-min. brisk walk	40-min. brisk walk	40-min. brisk walk	20–30-min. run
WORKOUTS	3	4	4	4
CARDIO	1	1	2	2

WARM-UP EXERCISES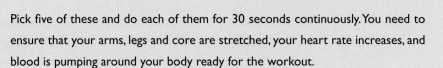

Pick five of these and do each of them for 30 seconds continuously. You need to ensure that your arms, legs and core are stretched, your heart rate increases, and blood is pumping around your body ready for the workout.

JOG ON THE SPOT

POWER JACKS

HIGH KNEES

BUTT KICKS

GRAB KNEES

HAMSTRING STRETCH

HIP-FLEXOR STRETCH

BODY-WEIGHT SQUATS

FORWARD LUNGES

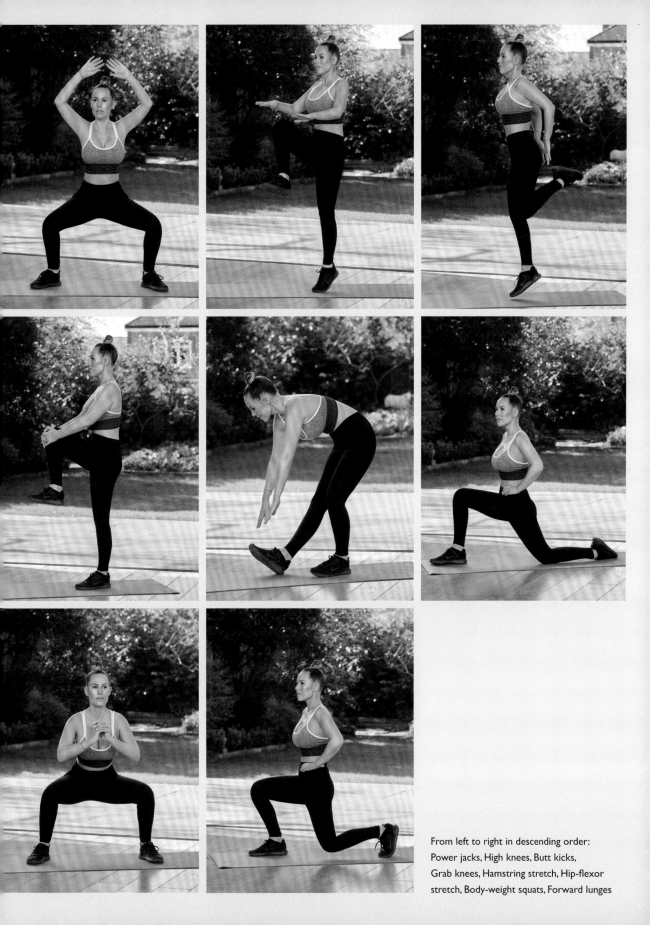

From left to right in descending order:
Power jacks, High knees, Butt kicks,
Grab knees, Hamstring stretch, Hip-flexor
stretch, Body-weight squats, Forward lunges

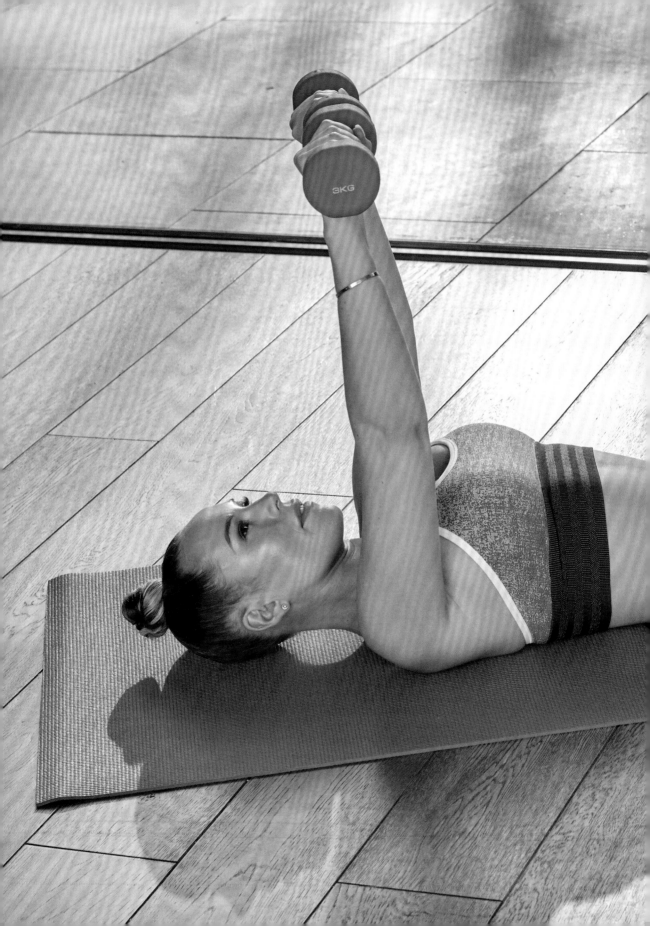

Week 1

WEEK 1 / MONDAY

UPPER BODY / LIGHT WEIGHTS

Let's start by working your arms, shoulders, chest and abs! They say three is a magic number, so you're going to do three sets of each exercise below, and in the first week you'll do 10–12 reps in each set. Take a breather between sets, put the weights down if you need to, and, when you've finished the third set, rest for 45 seconds before starting the next exercise. Day one, let's go!

WARM-UP

BICEP CURLS

CHEST PRESS

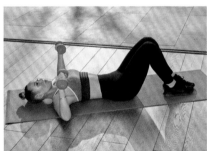

BENT-OVER DUMB-BELL ROWS

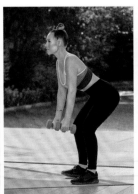
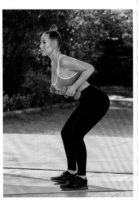

TRICEP EXTENSIONS

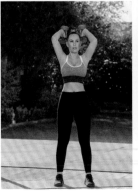

STANDING DUMB-BELL SHOULDER PRESS

FRONT DUMB-BELL RAISES

DOUBLE CRUNCHES

BICYCLE CRUNCHES

RUSSIAN TWISTS

COOL-DOWN

TOMORROW
rest day

WEEK 1 / WEDNESDAY

LOWER BODY / LIGHT WEIGHTS

Great, you've made it to day two! Today you'll work the muscles in your legs, glutes, back, and core with the same timings as yesterday: 10–12 reps, catch your breath, complete three sets, rest for 45 seconds, then on to the next exercise. These are all new movements, so take it steady, breathe, drink water, and enjoy it as much as you can!

WARM-UP

DUMB-BELL FRONT SQUATS

ROMANIAN DEAD LIFTS

SIDE LUNGES

WEIGHTED GLUTE BRIDGE

STANDING DUMB-BELL CALF RAISES

SQUAT JUMPS

DOUBLE CRUNCHES

 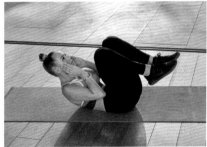

BICYCLE CRUNCHES

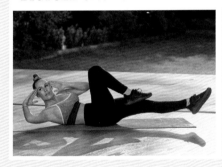 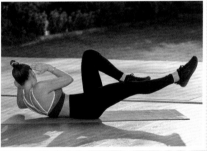

STANDING OBLIQUE CRUNCH

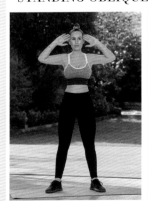

COOL-DOWN

TOMORROW
rest day

WEEK 1 / FRIDAY

FULL BODY / BODY WEIGHT

This is a HIIT (high-intensity interval training) workout, so rather than counting reps you need to put all of your energy into every exercise and keep your heart rate pumping all the way through.

This time you do 25 seconds of each exercise at maximum intensity, rest for 10 seconds and then move on to the next one. If you still have energy to carry on at the end, go back to the start and make it a 30-minute workout – you'll feel amazing, I promise!

WARM-UP

POWER JACKS

MOUNTAIN CLIMBERS

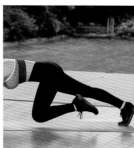

PLANK GET-UPS

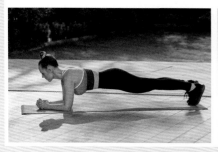
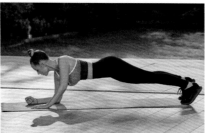
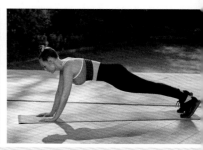

PLANK SHOULDER TAPS

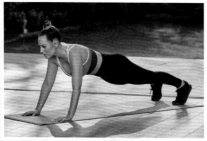
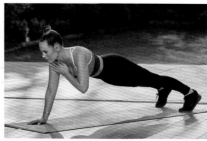

LOW BURPEES

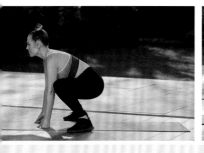 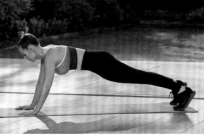

SQUAT JUMPS

STANDING OBLIQUE CRUNCH

HIGH KNEES

JACKKNIFES

FROG CRUNCHES

COOL-DOWN

WEEKEND EXERCISE
30–40-minute brisk walk

Week 2

Right, let's get back to those all-important arms, abs and shoulders! You're still doing three sets of each exercise, but we want to increase your strength as we go along. This week it's 12–15 reps in each set, followed by a 30-second rest. Remember, if you aren't sure how to do any of the exercises, refer to the glossary at the back!

WARM-UP

TWIST-IN SHOULDER PRESS

LATERAL DUMB-BELL RAISES

BENT-OVER DUMB-BELL ROWS

BENT-OVER DUMB-BELL FLIES

PRESS-UPS

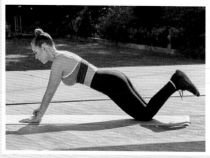
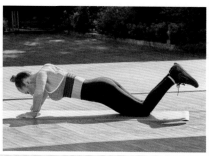

TRICEP EXTENSIONS

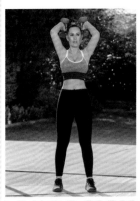 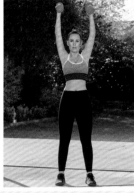

BICEP CURLS

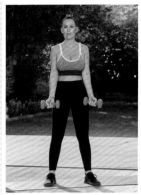 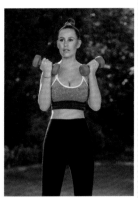

JACKKNIFES

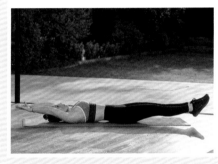 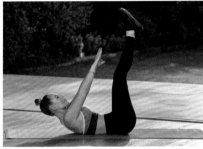

TOE TOUCHES

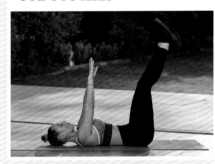 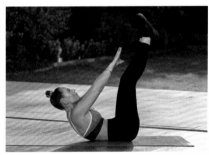

BICYCLE CRUNCHES

COOL-DOWN

WEEK 2 / TUESDAY

FULL BODY / BODY WEIGHT

I love to do this workout when I need to let off a lot of steam, so I hope you enjoy it too. It's another HIIT session where you'll be working your whole body. This time we're going to get your heart rate up by doing each exercise for 35 seconds, followed by a 25-second rest, and then straight on to the next exercise. Once you've done all 10, go back to the start and repeat again. You've got this!

WARM-UP

HIGH KNEES

BOXER PUNCHES

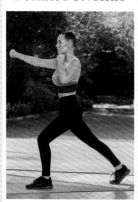

MOUNTAIN CLIMBERS

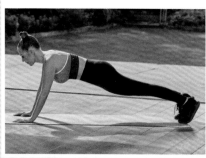
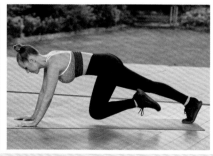

PRESS-UPS

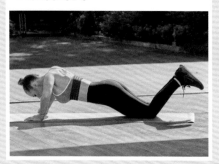

PLANK SHOULDER TAPS

LOW BURPEES

CURTSY LUNGES

BODY-WEIGHT SQUATS

SQUAT AND KNEE DRIVES ACROSS BODY

POWER JACKS

COOL-DOWN

TOMORROW rest day

WEEK 2 / THURSDAY

LOWER BODY / LIGHT WEIGHTS

We can slow it down today but you should feel the burn in your legs, bum and tummy. Again, you're doing three sets of each exercise, with 12–15 reps in each set, followed by a 30-second rest. Take these steady, tense the muscles you are working and focus on your form with each rep for the maximum results.

WARM-UP

DUMB-BELL FRONT SQUATS

ROMANIAN DEAD LIFTS

SPLIT SQUATS

STANDING DUMB-BELL CALF RAISES

WEIGHTED GLUTE BRIDGE

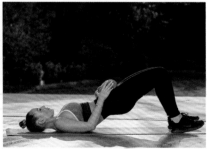

DUMB-BELL KICKBACKS

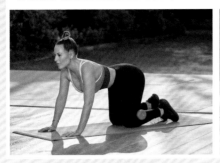 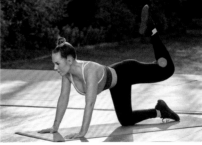

JACKKNIFES

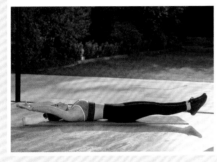 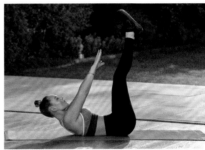

TOE TOUCHES

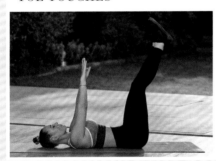 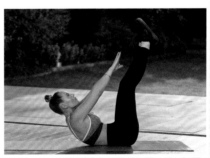

LEG RAISES

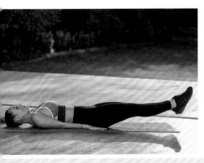 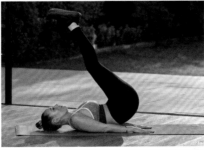

ANKLE TAPS

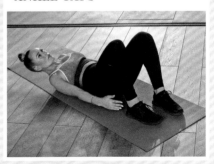

COOL-DOWN

WEEK 2 / FRIDAY

<div align="right">

FULL BODY / LIGHT WEIGHTS

</div>

You've already worked hard this week so this one might be extra tough, but the weekend is just around the corner! It's another HIIT workout to get your heart rate up: 35 seconds' work, 25 seconds' rest, and then on to the next exercise. Once you've finished all 10, go back to the start and repeat again and push to the very end.

WARM-UP

REVERSE LUNGES WITH SINGLE-ARM SHOULDER PRESS

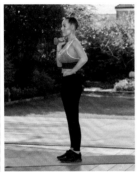
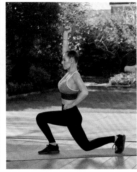

SQUAT JUMPS

REVERSE LUNGES WITH CURLS

POWER JACKS

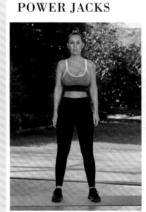
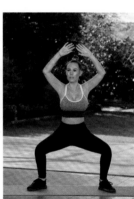

CHEST PRESS

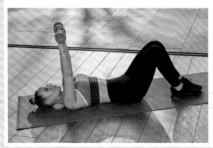
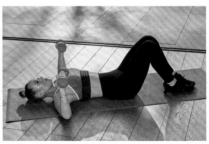

RENEGADE DUMB-BELL ROWS

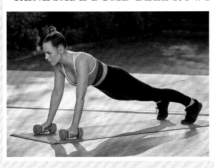
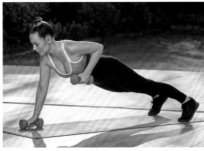

PRESS-UPS

SQUAT THRUSTS

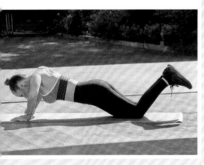
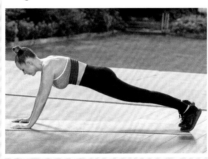
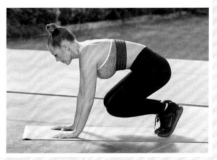

LOW BURPEES

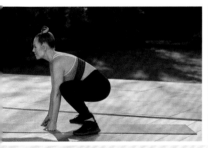
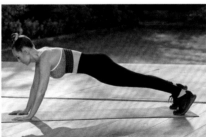
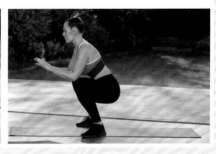

PLANK JACKS

COOL-DOWN

WEEKEND EXERCISE 40-minute brisk walk

Week 3

WEEK 3 / MONDAY

You're over halfway! Let's start off this week with another fun HIIT workout: you're going to do all 10 exercises and then repeat from the start, but this time it's 40 seconds' work, then 20 seconds' rest. Your body should be responding to the gradual increase in work but remember to breathe, drink water, and believe in yourself!

WARM-UP

CURTSY LUNGES

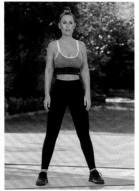
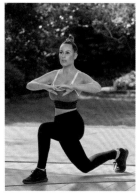

SUMO DUMB-BELL SQUATS

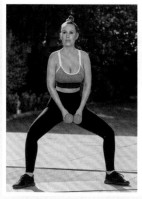
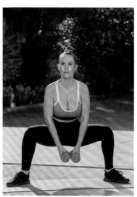

DUMB-BELL SWINGS

RENEGADE DUMB-BELL ROWS

MOUNTAIN CLIMBERS

FRONT PLANK

BURPEES

 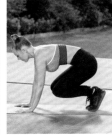 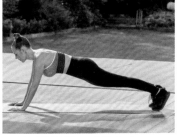 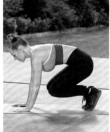 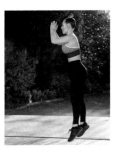

DUMB-BELL CLEAN PRESS

REVERSE LUNGES WITH CURLS

DUMB-BELL FRONT SQUATS

COOL-DOWN

WEEK 3 / TUESDAY

Hopefully you're starting to feel a bit stronger in your upper body by now, so we're going to work hard today. You will do three sets of each exercise, but each set is 15–20 reps, with a breather between each set and 30 seconds' rest before the next exercise. Your arms and shoulders should really feel it, but remember: the burn means results!

WARM-UP

DUMB-BELL CLEAN PRESS

TRICEP EXTENSIONS

TWIST-IN SHOULDER PRESS

CHEST PRESS

BENT-OVER DUMB-BELL ROWS

UPRIGHT DUMB-BELL ROWS

FRONT DUMB-BELL RAISES

FROG CRUNCHES

 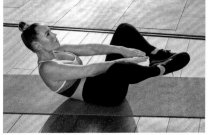

LEG RAISES

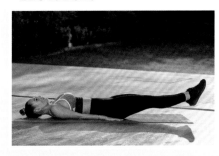 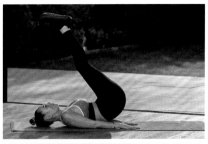

RUSSIAN TWISTS

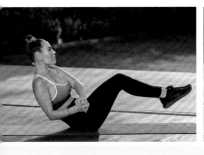

ANKLE TAPS

COOL-DOWN

TOMORROW 20–30-minute jog

WEEK 3 / THURSDAY

LOWER BODY / LIGHT WEIGHTS

Just like Tuesday you're going to do 15–20 reps, repeat for 3 sets with a breather in between, followed by a 30-second rest. BUT there are three supersets where you will not take your rest at the end, so you've got to push through 9 consecutive sets with just a breather between each. Trust me, it will be worth it!

WARM-UP

DUMB-BELL FRONT SQUATS

ROMANIAN DEAD LIFTS

SIDE LUNGES

SPLIT SQUATS (3 SETS, NO REST)

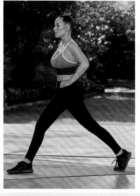
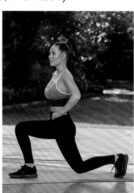

DUMB-BELL KICKBACKS (3 SETS, NO REST)

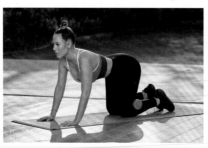
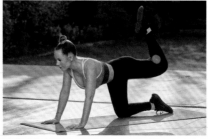

FIRE HYDRANT (3 SETS, NO REST)

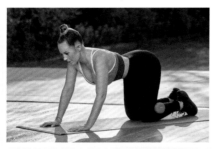 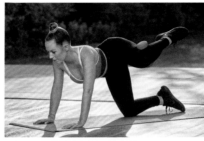

BUTTERFLY GLUTE BRIDGE

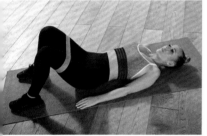 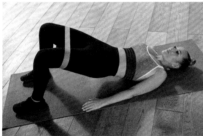

DOUBLE CRUNCHES

JACKKNIFES

 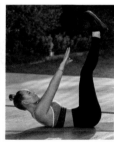

BICYCLE CRUNCHES

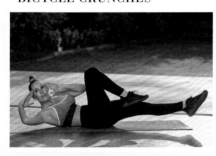 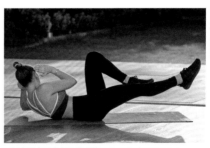

COOL-DOWN

WEEK 3 / FRIDAY

WEEK 3 / FRIDAY

FULL BODY / BODY WEIGHT

I picked some of my favourite exercises to finish off this week with a classic HIIT session, so turn your music up and get ready to do all 10 exercises: 40 seconds' work, 20 seconds' rest and repeat from the start. You know what they say, no pain no gain!

WARM-UP

JUMPING LUNGES

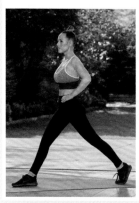

BROAD JUMP, LOW WALK-BACK

BURPEES

 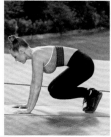 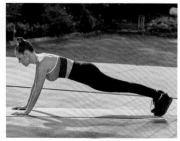 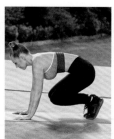 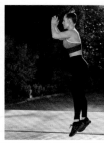

IN-AND-OUT SQUAT JUMPS

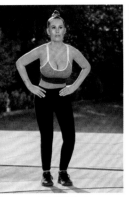 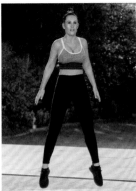 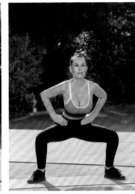

PRESS-UPS

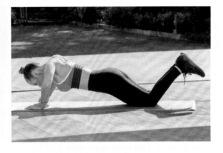

DUMB-BELL PUNCHES

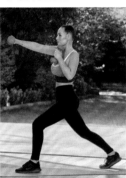

MOUNTAIN CLIMBERS

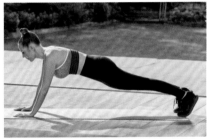 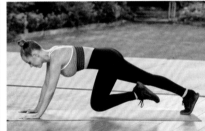

PLANK HIP DIPS

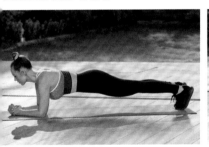 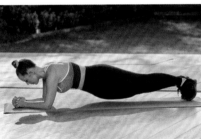 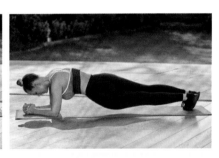

FRONT PLANK

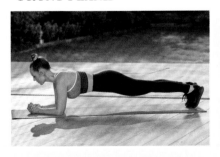

BODY-WEIGHT SQUATS

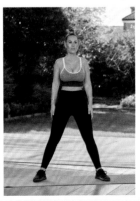 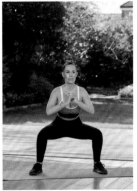

COOL-DOWN

WEEKEND EXCERISE
40-minute brisk walk

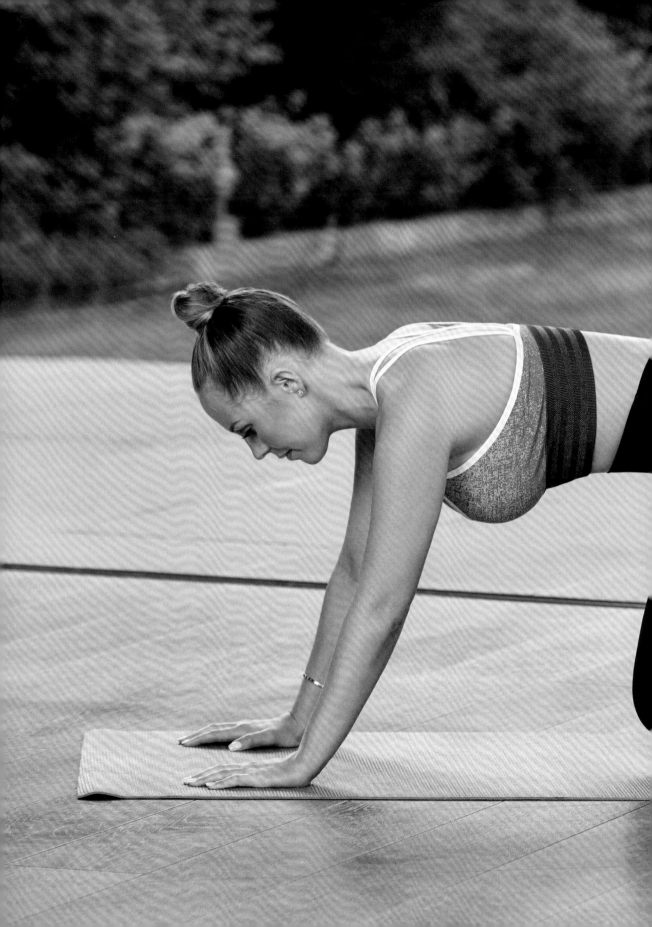

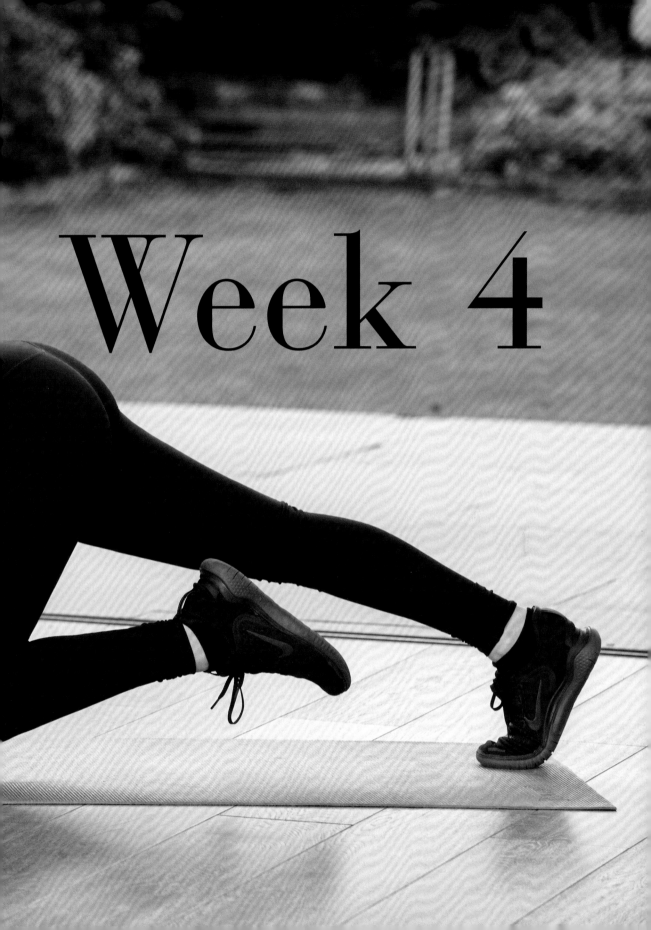

Week 4

WEEK 4 / MONDAY

FULL BODY / HEAVY WEIGHTS

It's the final week! Hopefully you're seeing results and pumped for the last few workouts! Let's celebrate how far you've come by getting stuck into another HIIT session. This time you're going to do each exercise for 45 seconds, rest for 15, and then go on to the next. Go through all 10 twice. Only one more HIIT to come!

WARM-UP

CURTSY LUNGES

DUMB-BELL FRONT SQUATS

REVERSE LUNGES WITH SINGLE-ARM SHOULDER PRESS

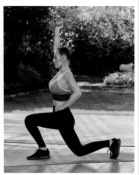

RENEGADE DUMB-BELL ROWS

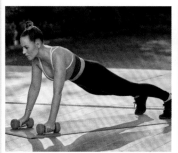
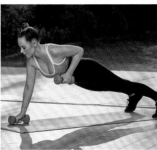

PLANK SHOULDER TAPS

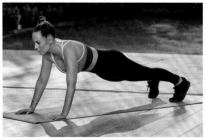
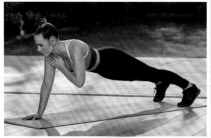

RUSSIAN TWISTS (WITH DUMB-BELL)

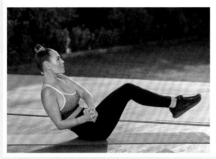 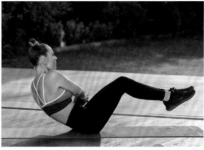

JACKKNIFES (WITH DUMB-BELL)

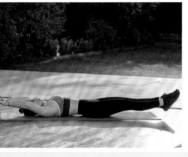 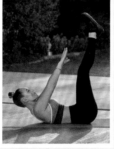

TOE TOUCHES (WITH DUMB-BELL)

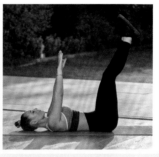 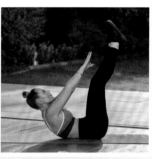

BURPEES

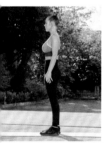 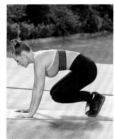 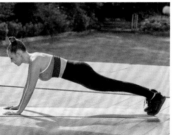 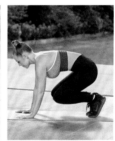

IN-AND-OUT SQUAT JUMPS

COOL-DOWN

WEEK 4 / TUESDAY

LOWER BODY / HEAVY WEIGHTS

This is the last push on your legs, bum and tummy – I want you to give it your all! You should have some heavier weights, so for each exercise do 10–12 reps, repeat for 3 sets with a breather in between, and then 30 seconds' rest. If you're still on the light weights, you need to do 20 reps in a set. Go for it!

WARM-UP

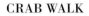

CRAB WALK

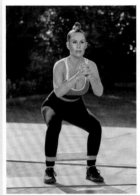 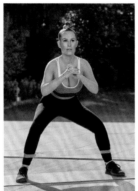

DUMB-BELL FRONT SQUATS

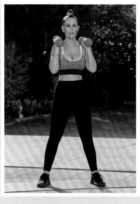

ROMANIAN DEAD LIFTS

SPLIT SQUATS WITH WEIGHTS

 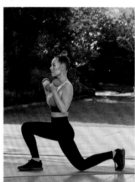

DUMB-BELL KICKBACKS

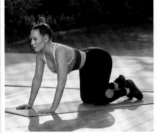 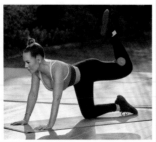

FIRE HYDRANT

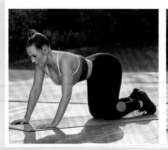

FROG PUMPS

JACKKNIFES

BUTTERFLY GLUTE BRIDGE

PLANK HIP DIPS

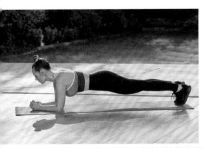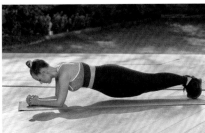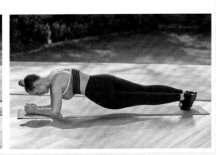

FRONT-PLANK PIKES

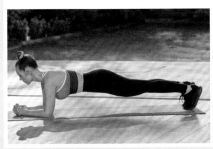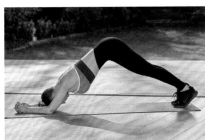

COOL-DOWN

TOMORROW 20–30-minute run

WEEK 4 / THURSDAY

UPPER BODY / HEAVY WEIGHTS

I bet your arms feel so much stronger than when we started! This workout is a great way to test how far you've come, so get those heavy weights and let's do 10–12 reps, repeat for 3 sets with a breather in between, and 30 seconds' rest. If you're still on light weights, it's 20 reps per set, no excuses!

WARM-UP

CHEST PRESS

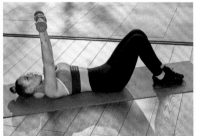
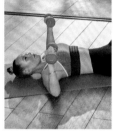

TRICEP EXTENSIONS

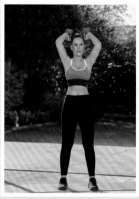
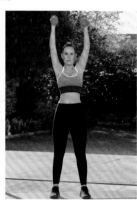

BENT-OVER DUMB-BELL ROWS

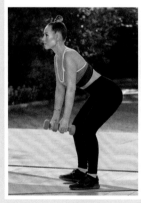
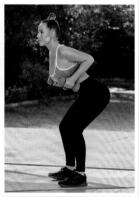

UPRIGHT DUMB-BELL ROWS

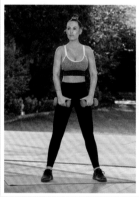

STANDING DUMB-BELL SHOULDER PRESS

AROUND-THE-WORLD DUMB-BELL RAISES

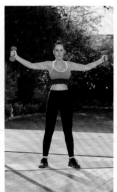
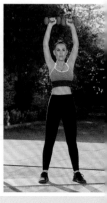

DUMB-BELL CLEAN PRESS

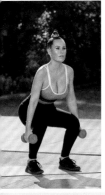 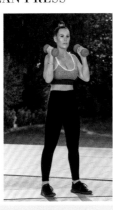

BICEP CURLS

DOUBLE CRUNCHES

 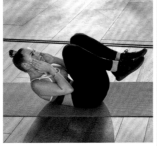

TOE TOUCHES (WITH DUMB-BELL)

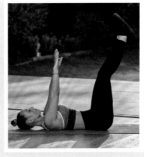 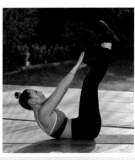

RUSSIAN TWISTS (WITH DUMB-BELL)

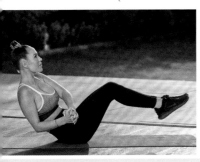 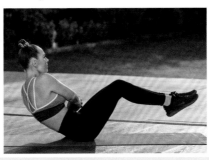

ANKLE TAPS

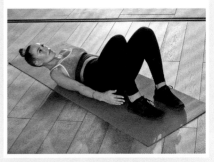

COOL-DOWN

This is it, the final workout! Complete your final 10 exercises and push as hard as you can for 45 seconds' work, 15 seconds' rest between each one, and repeat from the start! When you're done, take time to appreciate your body and all the things it has achieved over the last month! You did it!

WARM-UP

HIGH KNEES

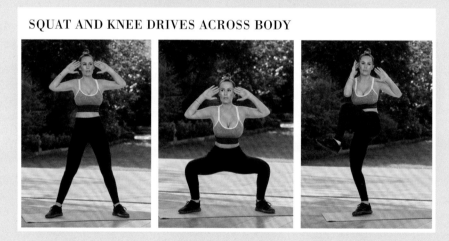

SQUAT AND KNEE DRIVES ACROSS BODY

BROAD JUMP, LOW WALK-BACK

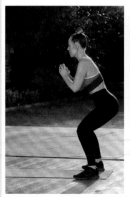

BURPEES

 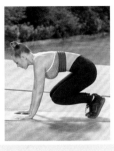 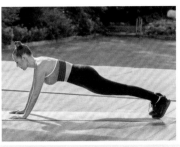 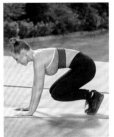

MOUNTAIN CLIMBERS

FRONT PLANK

DUMB-BELL PUNCHES

SQUAT JUMPS

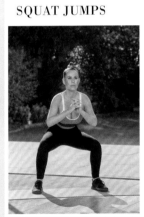 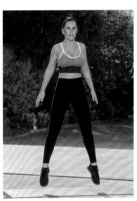

JUMPING LUNGES

PRESS-UPS

COOL-DOWN

WEEKEND EXCERISE
20–30-minute run

COOL-DOWN EXERCISES ♥

Do 2–3 minutes of 3–5 different stretches, holding each position for 30 seconds.

COBRA STRETCH

 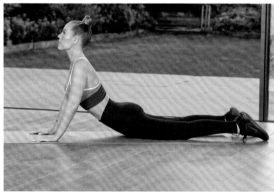

This stretches out your abdominal muscles so is good to do after an ab workout.

CHILD'S POSE STRETCH

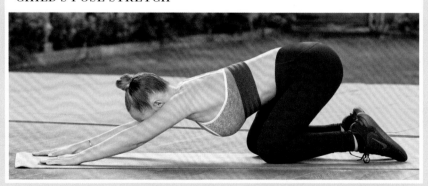

This helps the muscles in your lower back, as well as gently working your inner thigh muscles.

HIP-FLEXOR STRETCH

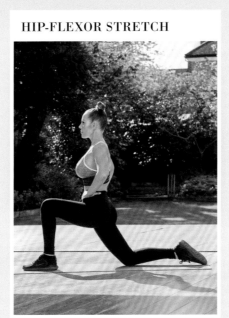

This helps you flex the hip muscles.

HAMSTRING STRETCH DOWNWARD DOG

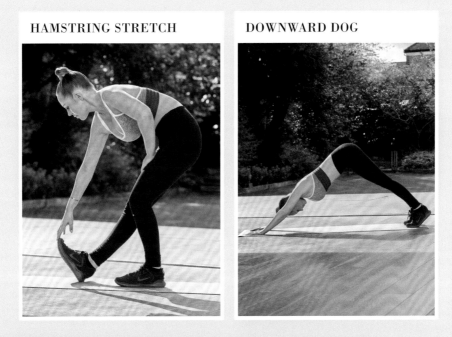

Both of these will stretch the back of your legs. Always do these after
a lower-body workout.

SOME OTHER SIMPLE STRETCHES THAT YOU CAN TRY TO
INCLUDE:

Chest stretch

1 / Stand up straight and interlace your fingers behind your back.

2 / Raise your hands to the ceiling and lift your chin up at the same time.

Tricep stretch

1 / Stand up straight and take your right elbow in your left hand.

2 / Lift your right arm over your head and allow your hand to drop to your
shoulder blade.

3 / Gently stretch and repeat on the other side.

Shoulder stretch

Cross your right arm across your body, holding it at the elbow with your left
hand. Gently stretch and repeat on the other side.

Hamstring stretch

Lie on your back and lift one leg. Hold your calf and gently pull your leg towards
you. Repeat on the other side.

Glute stretch

Lie on your back and bend your left leg. Place your right leg at a right angle over your left knee. Clasp your right hand behind the knee and gently pull it towards your chest. Repeat on the other side.

Quad stretch

Lie on your right-hand side and pull your left heel into the left glute so you feel a stretch in the front of the thigh. Repeat on the other side.

Lats stretch

Sit on the floor with your legs stretched out in front of you and your feet hip-width apart. Lift your right hand and reach over your head to the left-hand side. Repeat on the other side.

Adductor stretch

In the same position, with your feet slightly wider apart, gently arch your back and lean forward, stretching your arms out in front of you. Pulse forward so you can feel the stretch in your upper thighs.

Back stretch

Get down on all fours and arch your back, allowing your head to drop gently down. Then reverse the stretch, allowing your head to rise up so you look up at the ceiling.

Glossary
of exercises

Ankle Taps

1 / Lie on your back with your knees bent and your feet flat on the floor.

2 / Lift your shoulders off the ground and engage your core.

3 / Tap your right ankle with your right hand by stretching with your tummy muscles, not your shoulders or arms.

4 / Repeat on the other side.

5 / Rest in between reps if your neck becomes tired or strained.

Around-the-world dumb-bell raises

1 / Stand with your feet shoulder-width apart and dumb-bells in both hands by your hips with your palms facing forward.

2 / In a steady motion, keeping your palms facing forward at all times and your arms as straight as possible, lift the dumb-bells in one fluid motion from your hips to above your head.

3 / Hold them there for 2 seconds and then reverse the motion to return to the starting position.

Bent-over dumb-bell flies

1 / Holding a dumb-bell in each hand, stand with your feet shoulder-width apart and your knees slightly bent.

2 / Bend forward at the hips, keeping your back straight.

3 / Lift both arms to the side, maintaining a slight bend at the elbows and squeezing your shoulder blades together, then return to the starting position.

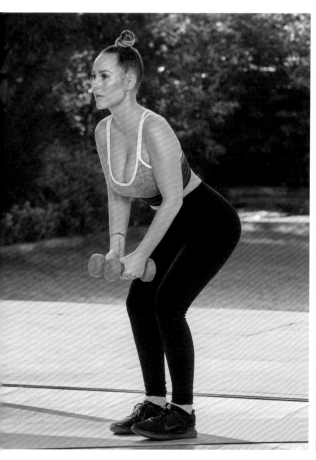
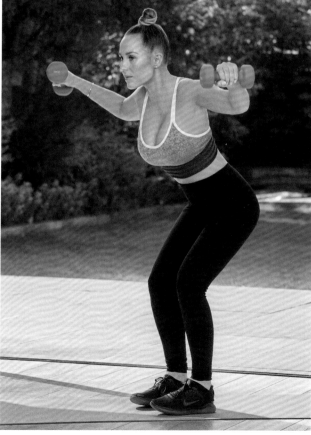

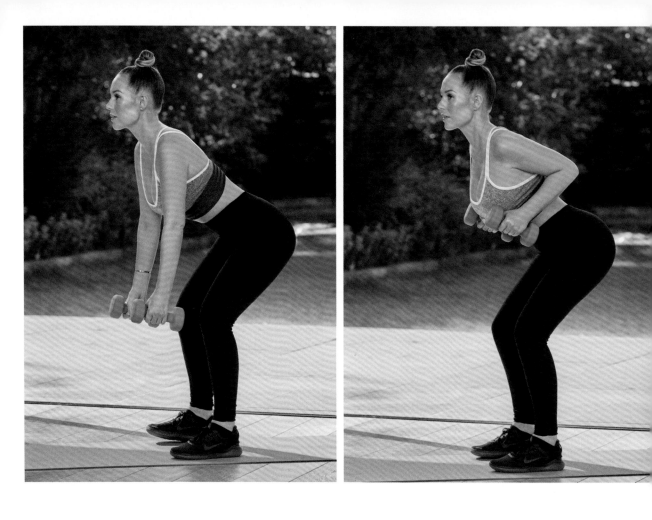

Bent-over dumb-bell rows

1 / Stand with your feet shoulder-width apart and a dumb-bell in each hand.

2 / Bend at the hips and knees and stretch your arms out straight towards the floor.

3 / Bend both arms at the elbow, bringing your dumb-bells up towards your torso and tensing your abdominal and back muscles as you do so.

4 / Return your arms to the starting position.

Bicep curls

1 / Stand up straight with your arms down by your sides. Hold a dumb-bell in each hand with your palms facing forward.

2 / Keep your elbows close to your torso and raise your hands towards your shoulders.

3 / Return to the starting position and repeat the exercise in a controlled manner.

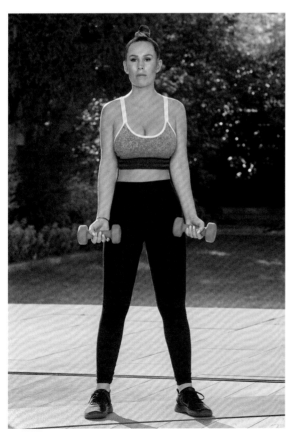

Bicycle crunches

1 / Lie on your back and bend your chin down towards your chest, allowing your shoulders to roll slightly in.

2 / Place your hands on the sides of your head with your elbows out, and then raise your legs into a tabletop position and point your toes.

3 / Engage your abs and twist so that your left elbow is trying to touch your right knee, allowing the other leg to extend straight out.

4 / Repeat on the other side.

Body-weight squats

1 / Stand with your feet slightly further than shoulder-width apart.

2 / Looking straight ahead, bend at the hips and knees, ensuring your knees point towards your toes.

3 / Continue bending as though sitting into a low chair behind you while keeping your back straight and your head up. You may stretch your arms out straight in front of you for balance.

4 / Push up through your heels and glutes to return to a neutral standing position.

5 / Repeat steps 2–4.

Boxer punches

1 / Place one foot in front of the other, shoulder-width apart.

2 / Hold your hands up at chest height and alternate punching each hand forward. Tense your core as you do so.

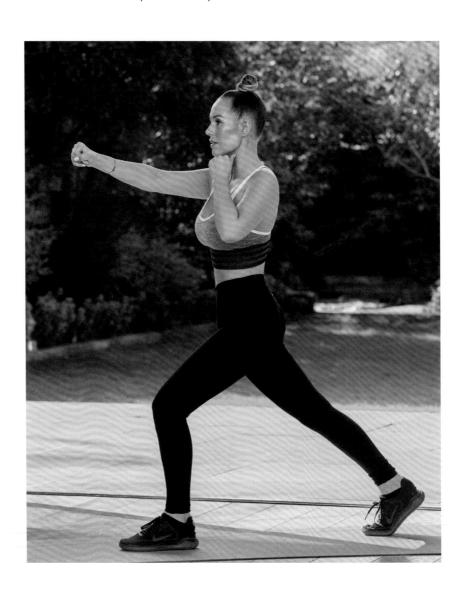

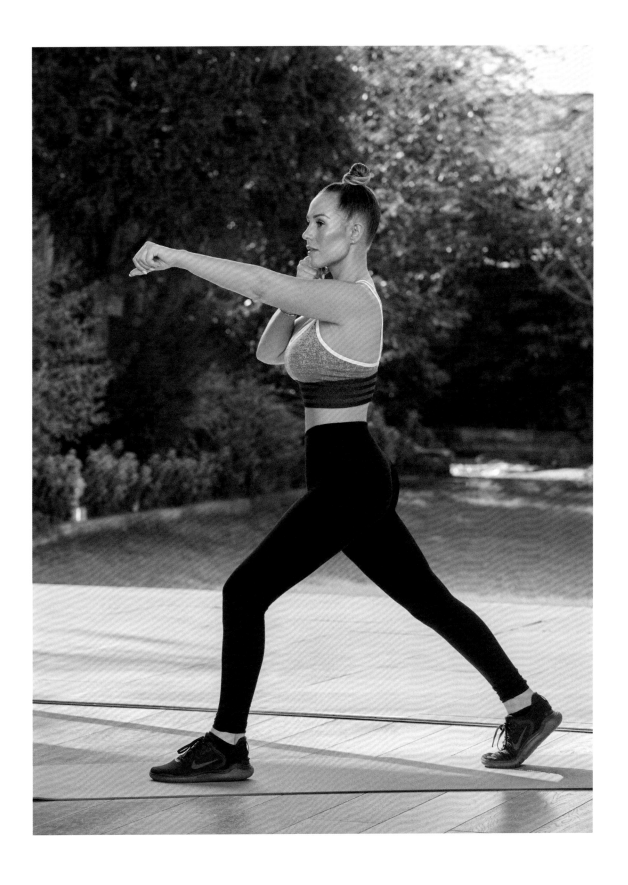

Broad jump, low walk-back

1 / Start standing with your knees slightly bent and lots of space in front of you.

2 / Jump as far forward as you can and as you land bend your knees.

3 / Then, keeping your knees bent, take big steps backwards to get to your starting position.

4 / Keep your back straight and tense your core throughout. Repeat.

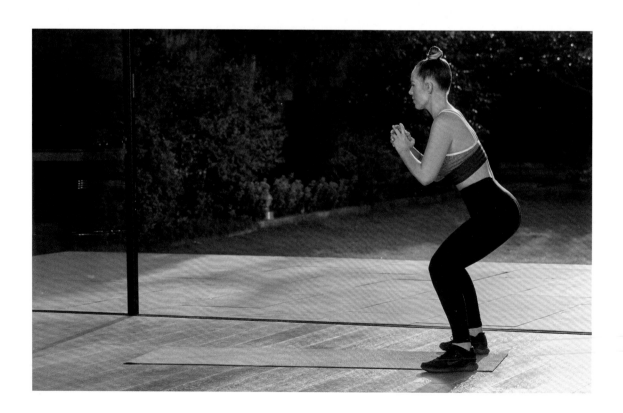

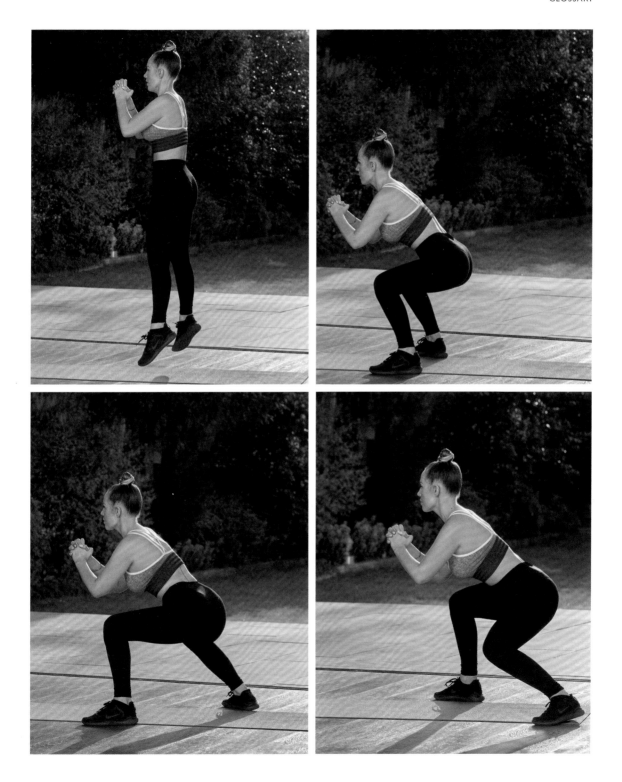

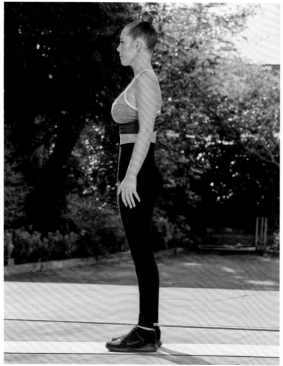 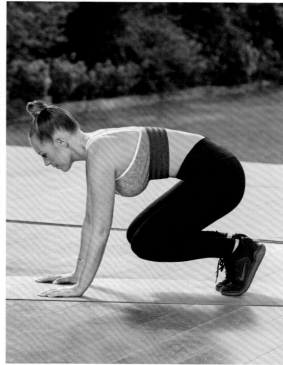

Burpees

1 / From a standing position, squat down and place your hands on the floor in front of you, shoulder-width apart.

2 / Kick your feet back so that you are in the straight-arm plank position.

3 / Quickly jump your feet back to the previous position.

4 / Jump straight up as high as you can and then drop down to the low squat and repeat.

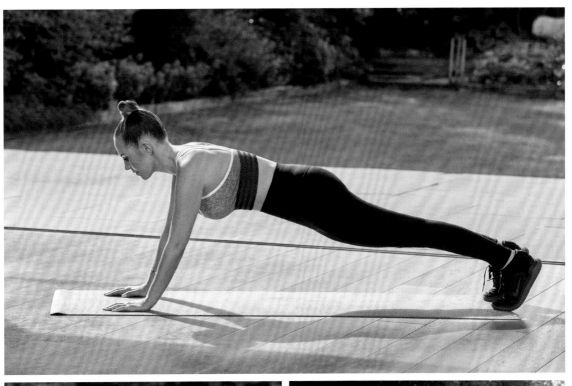

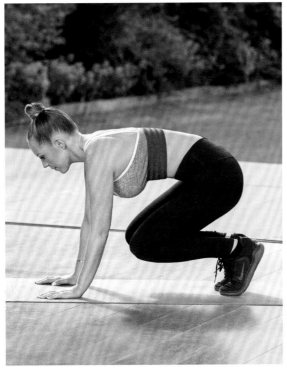

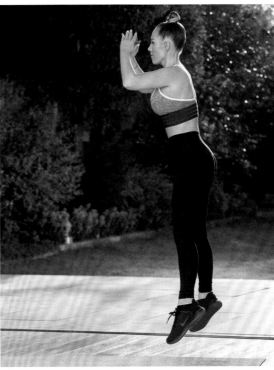

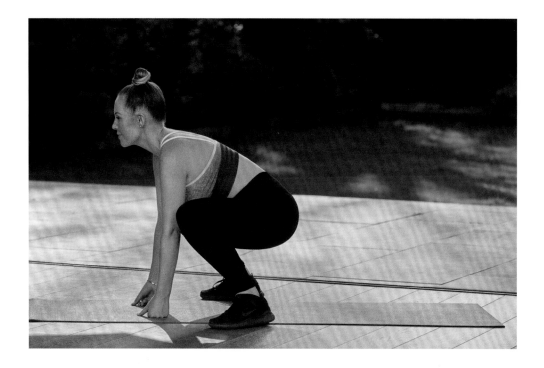

Burpees (low)

1 / Start with your feet planted wide apart and your knees bent into a crouching position.

2 / Put your hands on the ground in front of you and quickly kick your feet back into a straight-arm plank position.

3 / Then jump your feet back up and lift your hands up in front of you.

4 / Repeat.

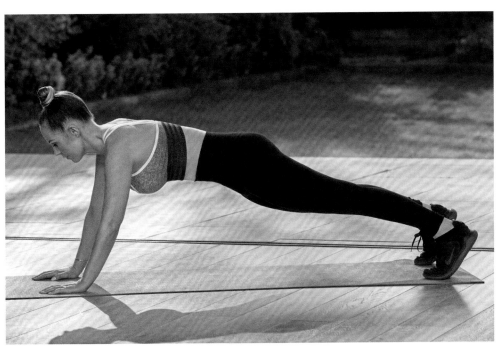

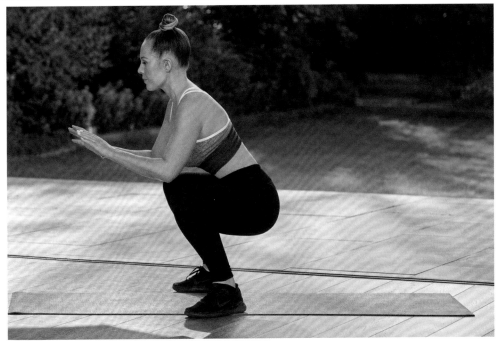

Butt kicks

1 / Stand up straight with your feet together. Hold your hands behind your back, resting them against your bum, palms facing out.

2 / Kick back with your left leg, raising your heel to touch your palm.

3 / Return your foot to the floor and alternate with your right leg.

4 / Repeat, alternating legs at speed.

Butterfly glute bridge

1 / Lie on your back with a resistance band just above the knees. Bend your knees and keep your feet flat on the floor.

2 / Raise your hips and squeeze your glutes as hard as you can. Spread your knees out. Hold the position for 2 seconds.

3 / Return your knees to centre and lower back down to the starting position.

Chest press

1 / Lie on the floor with your legs bent and your feet firmly on the floor.
Hold one dumb-bell in each hand with your elbows at ninety degrees.

2 / Straighten your arms and extend the dumb-bells towards the ceiling so
they are directly above you.

3 / Pause at the top before returning to the starting position.

Child's pose stretch

1 / Sit on your heels and hold your arms out in front of you.

2 / Reach forward so that your head is almost touching the floor and continue to keep stretching your arms as far forward as you can.

Cobra stretch

1 / Lie on your front with your hands palm down and positioned underneath your shoulders.

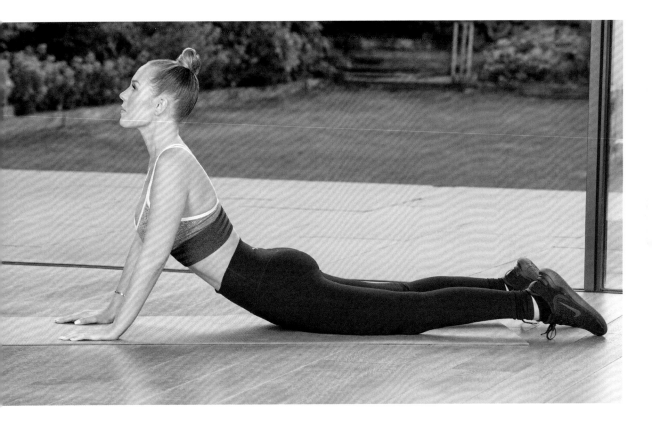

2 / Push up on your hands, looking straight forward as you feel the stretch in your abdominals, then hold.

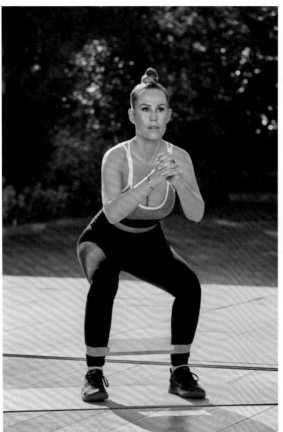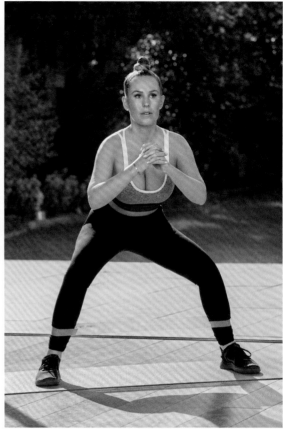

Crab walk

1 / With a resistance band round your ankles and your feet shoulder-width apart get into a squat with your hands in front of you or wherever they feel most comfortable.

2 / Step your left foot out so that you are in a wide squat stance.

3 / Then step your right foot to the left to return to a squat.

4 / Step out with your right foot, following with the left, and so on, always maintaining your squat stance.

Curtsy lunges

1 / Start from a standing position with your legs hip-width apart.

2 / Step your left leg behind you to the right so your thighs cross over, and bend both knees as if you're curtsying. Ensure your front knee is aligned with your front ankle.

3 / Hold for 2 seconds and then return to the starting position.

4 / Repeat on the other side.

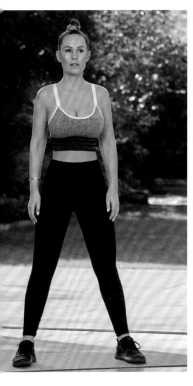
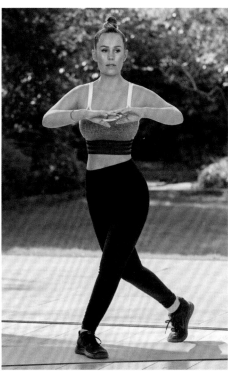
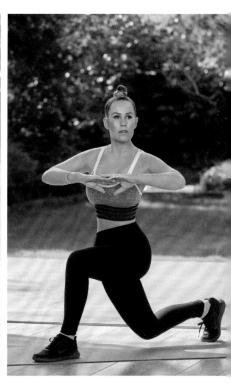

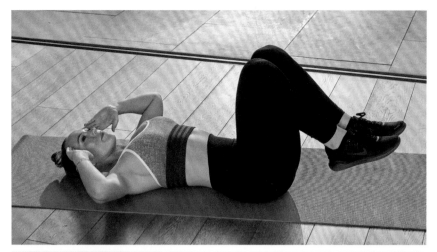

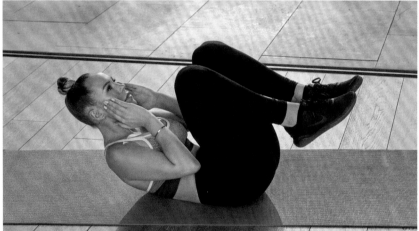

Double crunches

1 / Lie on your back with your knees bent and your feet hip-width apart and flat on the floor.

2 / Engage your core and gently pull your abs in. Curl forward so your upper body lifts off the floor.

3 / Slowly raise your knees and curl them up towards your chest.

4 / Hold for 2 seconds at the top of the movement and then lower slowly back down to the starting position.

Downward dog

1 / Begin on your hands and knees.

2 / Lift your bum, raising your knees and straightening your legs.

3 / With your arms and legs straight and head looking towards your feet, feel the stretch in your arms and legs and hold for at least 30 seconds.

Dumb-bell clean press

1 / With your feet shoulder-width apart and dumb-bells in both hands by your sides, bend your knees into a standard squat.

2 / Push your body up into a standing position, using the push from your legs to lift the dumb-bells to your shoulders.

3 / Push again through your knees to lift the dumb-bells above your head with straight arms.

4 / Hold there for one second before bringing the dumb-bells back to your shoulders, then your sides, then move back to a squat.

Dumb-bell front squats

1 / Stand with your feet slightly wider than shoulder-width apart and hold
a dumb-bell in each hand by your shoulders.

2 / Focus on a point in front of you so your head and shoulders stay stable.
Lower your hips and push your knees outwards so they are in line with
your toes.

3 / Squat down so your hips are in line with the backs of your knees.

4 / Press through your feet and rise back to the starting position.

Dumb-bell kickbacks

1 / Starting on your hands and knees with both shoulder-width apart, tuck a dumb-bell into the crease at the back of your knee.

2 / Then lift your leg up behind you until your thigh is parallel to the floor, keeping your knee bent throughout the movement.

3 / Slowly return to starting position and then repeat.

Note / To make this exercise easier, do it without the dumb-bells.

Dumb-bell punches

1 / Place one foot in front of the other, shoulder-width apart.

2 / Hold a dumb-bell in each hand, holding your hands up at chest height, and alternate punching each hand forward. Tense your core as you do so.

Dumb-bell swings

1 / Start with your legs slightly bent and your feet wider than shoulder-width apart. Lean forward with a straight back and a dumb-bell in each hand within your knees.

2 / Push up quickly with the back of your thighs and glutes into a standing position and use the momentum to swing your arms above your head.

3 / Hold for one second and then swing back down into the starting position and repeat. Keep your back straight and abs tense throughout.

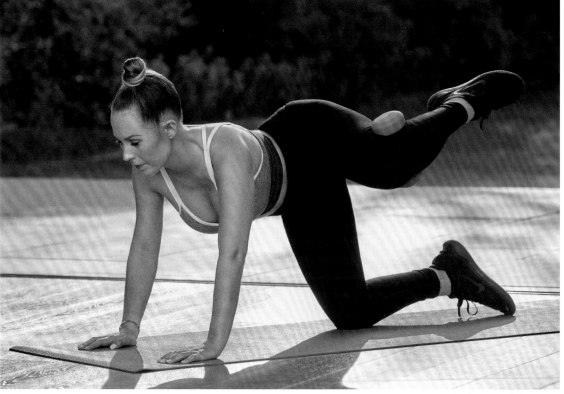

Fire hydrant

1 / Start with your hands and knees on the ground with your back flat like a tabletop and your hands shoulder-width apart. You can add a dumb-bell to the crease of your knee to make this harder, but start off without until you feel comfortable in the position.

2 / Lift your left knee out and up to your left side, keeping your knee bent all the time. Facing forward, tense your glutes and keep your head and core steady.

3 / Return your knee to the floor and repeat the fluid motion out and in.

4 / Do the required amount of reps and then change to the other leg.

Forward lunges

1 / Stand with both feet shoulder-width apart.

2 / Step forward with your right leg, bending it at the knee. Dip your left knee towards the floor.

3 / Push back up through your glutes and step back until both feet are side by side again.

4 / Repeat on the other side.

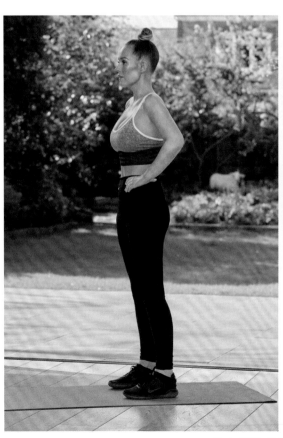
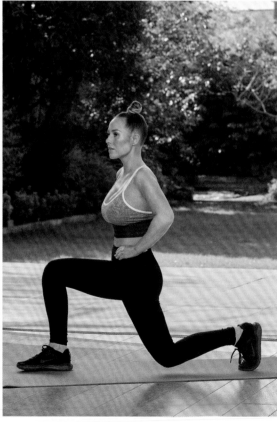

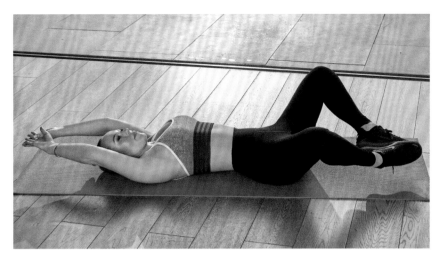

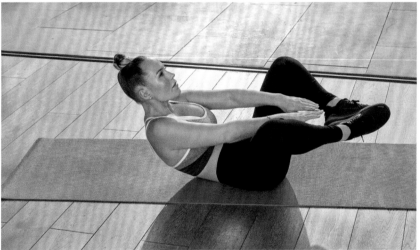

Frog crunches

1 / Lie on your back with your arms above your head. With your feet touching, bend your knees and spread them apart.

2 / Reach your hands to your toes by tensing your core, keeping your arms straight and lifting your shoulders off the ground while crunching your knees up.

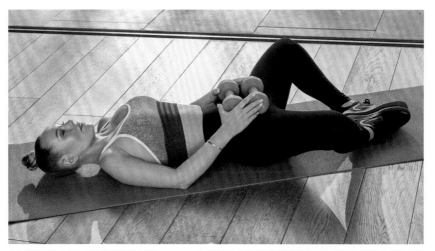

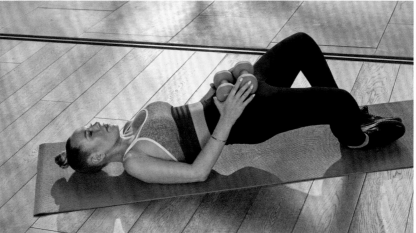

Frog pumps

1 / Lie on your back with your knees bent and your feet together
and one or two dumb-bells across your hips. Spread your knees apart.

2 / Lift your hips, tensing your glutes and core with your knees apart.
Keep your shoulders on the ground.

3 / Return to the starting position and repeat.

Front dumb-bell raises

1 / Hold a dumb-bell in each hand with your hands resting straight down in front of you, shoulders rolled back and relaxed, palms facing in to your body.

2 / Raise both hands together in a straight movement until your arms are at a ninety-degree angle to your body.

3 / Lower your hands back to the starting position and repeat.

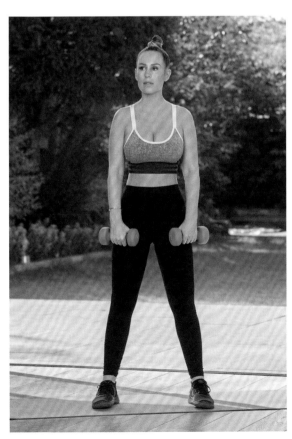

Front plank

1 / Begin by lying face down on the floor. Go up on your tiptoes and place your elbows directly under your shoulders, slightly wider than shoulder-width apart, to support your weight.

2 / Push your toes into the floor, squeeze your glutes and tighten your abs. Keep your body straight and your bottom lowered. Fix your gaze on a spot on the floor just in front of your hands.

3 / Hold the position for a minimum of 20 seconds, or as long as instructed in the workout you are doing.

Front-plank pikes

1 / Start in a front plank position with your hands together in front of you and your elbows on the ground, shoulder-width apart. Keep your back as straight as possible.

2 / Lift your hips as high as possible while keeping your elbows and feet in the same position.

3 / Return to the front plank position and then repeat.

Grab knees

1 / Stand with your feet less than shoulder-width apart.

2 / Raise your right knee as far as you can and hold it to your body.
 Maintain this position for at least 30 seconds to stretch your thighs
 and quads.

3 / Repeat on the other leg.

Hamstring stretch

1 / Stand with your left foot planted on the ground and your left knee slightly bent.

2 / Stretch your right leg out straight in front of you with just your heel touching the ground.

3 / Stretch your arms straight above your head.

4 / Reach down towards your outstretched toe and hold.

5 / Repeat on the other side.

High knees

1 / Stand up straight with your feet positioned together.

2 / Hold your hands out at waist height, palms facing down.

3 / Bring your left knee up and try to pull it up high enough to touch your hands, then return your foot to the ground.

4 / Do the same with your right knee and repeat, alternating as fast as you can.

Hip-flexor stretch

1 / Kneel on your right knee and place your left foot flat on the floor in front of you, knee bent.

2 / Lean forward, stretching your right hip towards the floor.

3 / Squeeze your bum; this will allow you to stretch your hip flexor more. Hold this position for at least 30 seconds.

4 / Repeat on the other side.

In-and-out squat jumps

1 / From a standing position with your feet together, jump up and land with your feet out wide to either side of you and bend your knees down into a sumo squat position.

2 / Jump straight up from the squat, returning your feet to centre, and repeat the motion in and out without stopping.

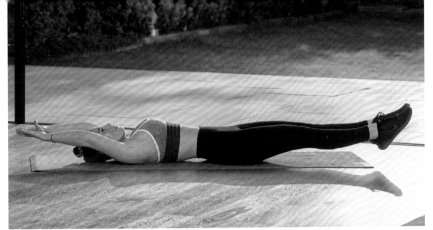

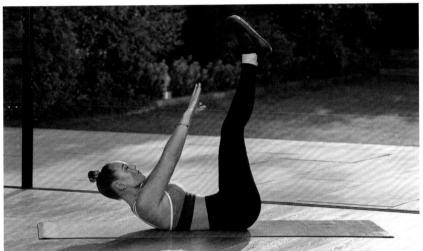

Jackknifes

1 / Lie on your back with your arms stretched above your head and
your legs flat.

2 / With your feet together lift your legs and reach your arms up towards
your toes, crunch your stomach muscles and lift your shoulders off
the ground without straining your neck.

3 / Slowly lower your legs and arms back to the starting position and
then repeat.

Note / To increase the intensity of this excerise, hold a dumb-bell in your hands
and keep your arms as straight as possible.

Jumping lunges

1 / Stand up straight with your right foot in front of you. Bend your knees slightly, but not so you're in a full lunge.

2 / Engage your core and use both feet to jump up, swapping your feet over in mid-air.

3 / Land in a lunge with your left foot in front.

4 / Repeat on the other side.

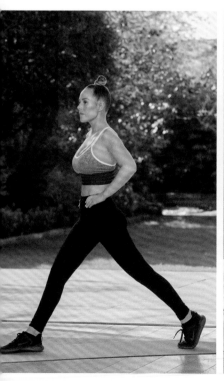
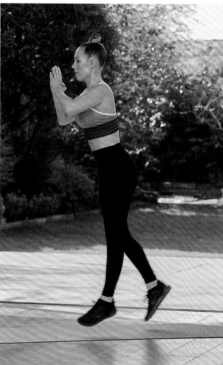

Lateral dumb-bell raises

1 / Stand up straight and hold a dumb-bell in each hand down by your sides.

2 / Engage your core and slowly lift the weights out to the side until your arms are parallel with the floor.

3 / Lower your arms slowly and return to the starting position.

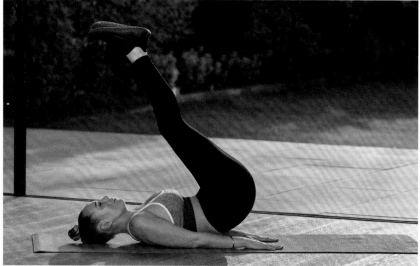

Leg raises

1 / Lie on your back with your arms down by your sides and your legs stretched out.

2 / Engage your core and raise your legs until your toes are pointing at the ceiling, keeping your legs as straight as possible.

3 / Lower your legs slowly until they are a few centimetres above the ground.

4 / Hold for 2 seconds and then raise the legs again.

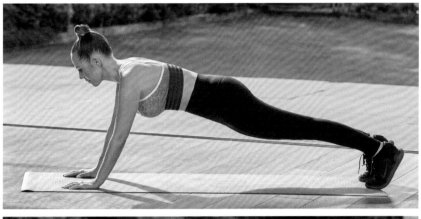

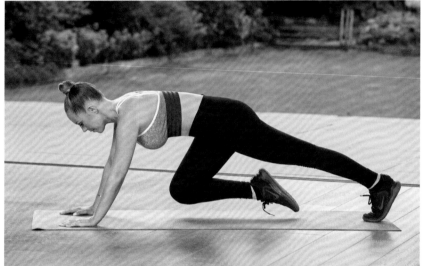

Mountain climbers

1 / Begin in a straight-arm plank position.

2 / Engage your core and bring your left knee forward under your chest.

3 / Return to the plank position and switch sides, bringing your right knee up to your chest.

4 / Alternate legs as quickly as possible.

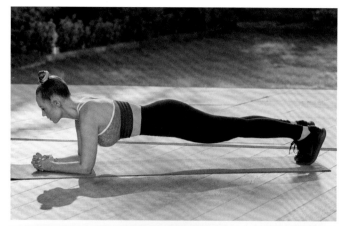

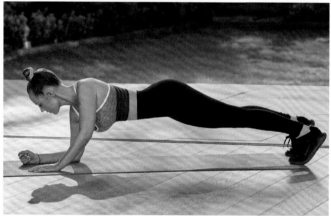

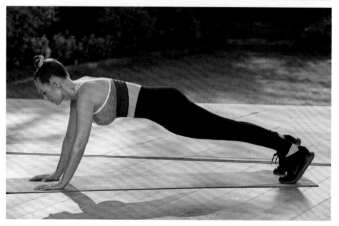

Plank get-ups

1 / Begin in a front plank position.

2 / Put your left hand down underneath
your shoulder, then your right to get
you into a straight-arm plank.

3 / Then go down onto your elbows one
arm at a time.

4 / Keep repeating.

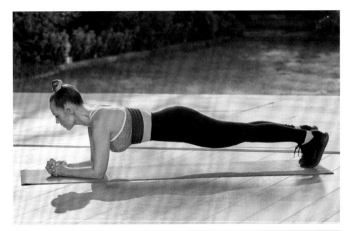

Plank hip dips

1 / Begin by lying face down on the floor.
Go up on your tiptoes and place your
elbows directly under your shoulders,
slightly wider than shoulder-width apart.

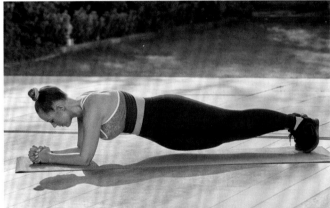

2 / Push your toes into the floor and
squeeze your glutes and tighten your
abs. Keep your body straight and your
bottom lowered. Fix your gaze on a spot
on the floor just in front of your hands.

3 / Tip your hips to the right so that your
right hip almost touches the ground.
Keep your core tense and legs straight.

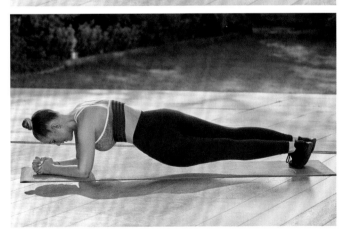

4 / Return your hips to the middle.

5 / Repeat on the other side.

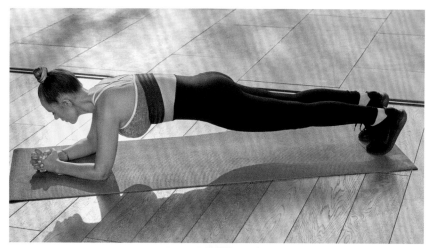

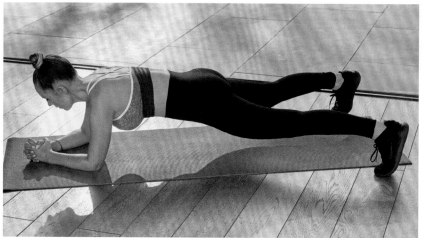

Plank jacks

1 / Start in a front plank position, with your hands together in front of you and your elbows on the ground, shoulder-width apart. Keep your back as straight as possible.

2 / Jump both feet out to either side. Try to keep your legs straight and try not to lift your hips as you jump.

3 / Hold for one second and then jump your feet back to centre.

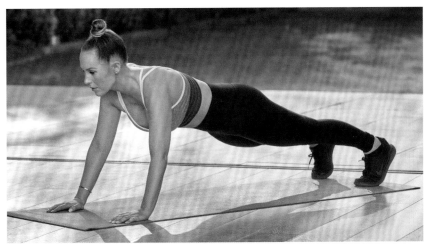

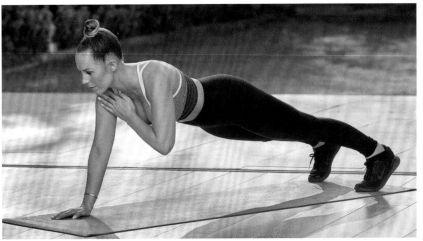

Plank shoulder taps

1 / Begin in a straight-arm plank position.

2 / Keeping as stable as possible, lift one hand to touch the opposite shoulder.

3 / Place your hand gently back on the floor.

4 / Repeat on the other side.

Power jacks

1 / Stand with your feet hip-width apart and hands by your side.

2 / Jump up, raising your arms straight above your head while spreading your legs wide.

3 / Jump back into the starting position and repeat immediately.

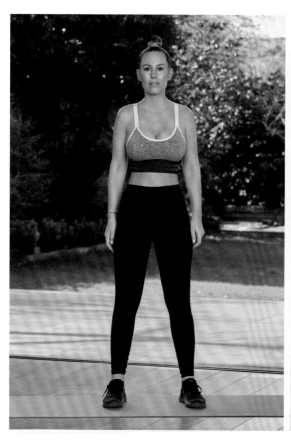
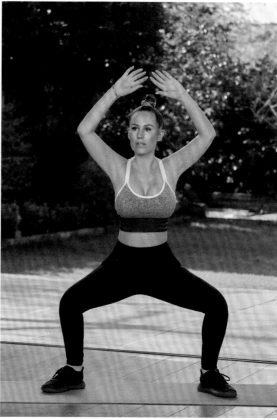

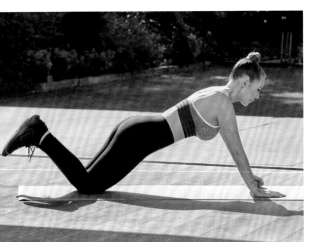 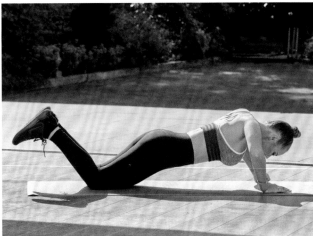

Press-ups

1 / Go down on all fours so your hands are slightly wider than your shoulders.

2 / Extend your legs back so that you are balanced on your hands and toes and your body is straight, or balance on your knees.

3 / Tighten your abs and pull in your core by pulling your belly button up towards your spine.

4 / Slowly bend your elbows and lower yourself until your elbows are at a ninety-degree angle.

5 / Push back up to the starting position and repeat.

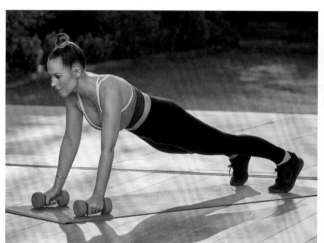 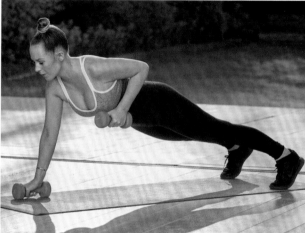

Renegade dumb-bell rows

1 / Get into a straight-arm plank position with your feet slightly wider than shoulder-width apart, gripping a dumb-bell in each hand. The dumb-bells should be underneath your shoulders and your arms should be locked. If the position feels too hard, bend your knees and cross one foot over the other.

2 / Tighten your core and pull your left arm up, working your triceps, so your upper arm is slightly higher than your torso.

3 / Return to the starting position.

4 / Repeat on the other side.

Reverse lunges with curls

1 / Holding a dumb-bell in each hand, stand up straight with your legs hip-width apart.

2 / Step back with your left foot.

3 / Drop down so that your left knee almost touches the ground while lifting the dumb-bells from your waist to your shoulders in front of you.

4 / Use your stomach muscles to help pull you up as you bring your left foot forward, then drop your arms and return to the starting position.

5 / Repeat on the other side.

Reverse lunges with single-arm shoulder press

1 / Holding a dumb-bell in your right hand, stand up straight with your legs hip-width apart.

2 / Step back with your left foot and drop down so your left knee almost touches the ground while lifting your right arm straight above your head.

3 / Return to the starting position and repeat for the required amount of reps.

4 / Move the dumb-bell to your other hand and repeat on the other side.

Romanian dead lifts

1 / Hold your dumb-bells at hip level with your knees slightly bent. Pull back your shoulders and arch your back a little.

2 / Lower the dumb-bells while pushing your bottom back as far as you can. Focus on a point in front of you to keep your head and chest up, and ensure your shoulders stay back.

3 / Push your hips forward and return to the starting position.

Russian twists

1 / Lie on your back and lift your feet off the ground with your knees at a right angle.

2 / Raise your upper body so it creates a V-shape with your thighs.

3 / Twist your whole torso to the right-hand side while balancing in the V-shape position.

4 / Then twist around to the left and repeat the motion quickly
but smoothly.

Note / To increase intensity, as instructed in Week 4, hold a dumb-bell with
both hands and touch it to the ground on either side as you twist.

Side lunges

1 / Stand with your feet shoulder-width apart and your hands together or on your hips – whatever feels most comfortable.

2 / Step out as far as you can with your left foot and bend your right knee, tensing your thigh and keeping your left leg straight.

3 / Step your left foot back to your standing position and then do the same on your right.

Split squats

1 / Lunge forward half a metre keeping your core muscles tight and your torso upright.

2 / Bend your front leg so your thigh is parallel to the floor.

3 / Use your core to straighten yourself back up to the starting position.

4 / Repeat on the other side.

5 / To make this exercise work harder for you, hold a dumb-bell in each hand.

Squat jumps

1 / Stand upright with your feet shoulder-width apart.

2 / Squat down, holding your arms out in front of you.

3 / Engage your core and jump up in the air as energetically as you can.

4 / When you land squat down straight away and then jump up and keep repeating.

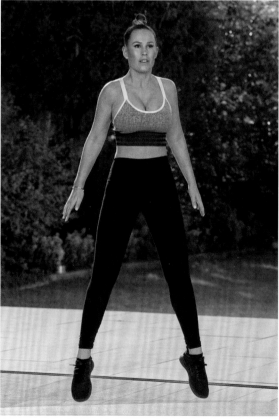

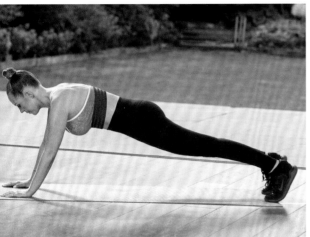 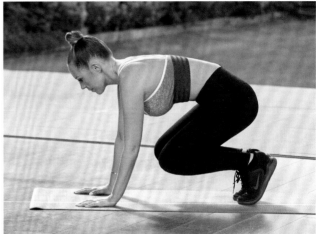

Squat thrusts

1 / Get into the straight-arm plank position.

2 / Keeping your back as straight as possible, jump your feet forward to the same level as your bum, tucking your knees towards your chest.

3 / Jump your feet back to the plank position.

4 / Jump in and out without stopping for the required amount of reps.

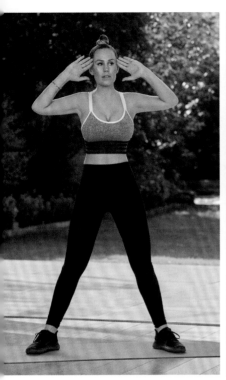

Squat and knee drives across body

1 / Stand with your feet wider than shoulder distance apart, with your feet pointing outwards and your hands by your head.

2 / Bend your knees and hips as you squat down and continue bending until your upper thighs are parallel with the floor, keeping your back straight and at an angle of forty-five to ninety degrees to your hips.

3 / Push up through your heels towards standing position, raising your left knee across your body until it touches your right elbow.

4 / Bring your knee back down to return to the starting position.

5 / Repeat on the other leg.

Standing dumb-bell calf raises

1 / Stand with your feet shoulder-width apart with a dumb-bell in each hand, your arms by your sides.

2 / Push your weight forward on to your tiptoes, raising your heels off the floor.

3 / Hold for a second, then return heels to the floor. Repeat for the required number of reps.

Standing dumb-bell shoulder press

1 / Stand with your feet shoulder-width apart and a dumb-bell in each hand.

2 / Lift the dumb-bells to head height with your elbows out at ninety degrees.

3 / Extend through your elbows so the weights are directly above your head.

4 / Slowly return to the starting position.

Standing oblique crunch

1 / Stand with your feet slightly wider than shoulder-width apart and hold your hands to your head.

2 / Rotate and raise your left knee, bringing it to touch your left elbow.

3 / Return your foot to the floor and repeat on the other side.

Sumo dumb-bell squats

1 / Stand with your feet wide apart, legs slightly bent and your toes pointing outwards with dumb-bells together in front of you.

2 / Keep your head and chest up and then do a low squat, bending your knees and lowering your bum towards the ground with the dumb-bells straight in front of you.

3 / Push through your glutes to the starting position and repeat.

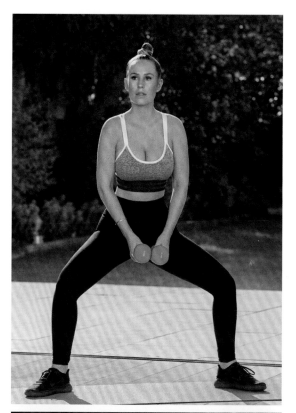

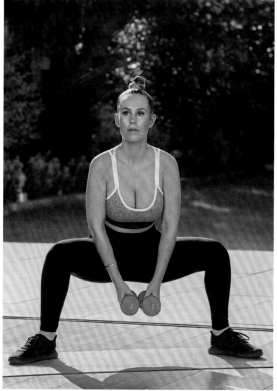

Toe touches

1 / Lie on your back with your arms straight up in front of you and your legs lifted as straight as you can.

2 / Crunch your core to lift your hands to your toes.

3 / Lift your shoulders off the ground and reach as far as you can for one second before returning to the starting position.

Note / To increase intensity, as instructed in Week 4, hold a dumb-bell at either end with both hands.

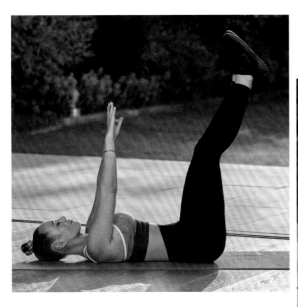

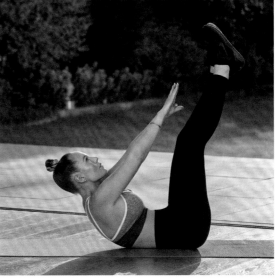

Tricep extensions

1 / Stand with your feet shoulder-width apart with a dumb-bell in each hand.

2 / Hold your weights behind your head with your arms bent.

3 / Straighten your arms out upwards.

4 / Return your arms to the starting position and repeat.

Twist-in shoulder press

1 / Stand with your legs hip-width apart, holding a dumb-bell in each hand.

2 / Raise your arms so they are level with your upper chest. Bend your elbows and keep your palms facing up.

3 / Raise the dumb-bells while rotating the palms of your hands so they are facing forward.

4 / Continuing lifting the dumb-bells until your arms are straight.

5 / Pause at the top before lowering your arms and rotating the palms of your hands back towards you. Repeat.

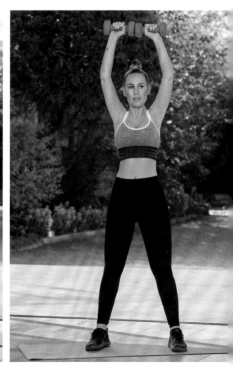

Upright dumb-bell rows

1 / Stand up straight and hold a dumb-bell in each hand with your palms facing in. Rest the dumb-bells on the top of your thighs. Your arms should be straight with a slight bend at the elbow.

2 / Bend your arms and lift the dumb-bells to shoulder height, keeping them close to your body.

3 / Lower the dumb-bells slowly and return to the starting position.

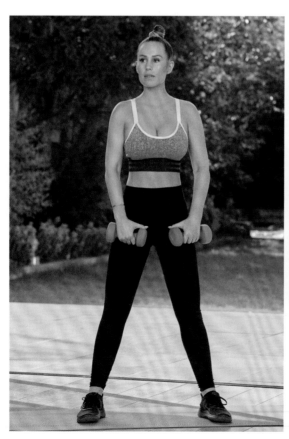
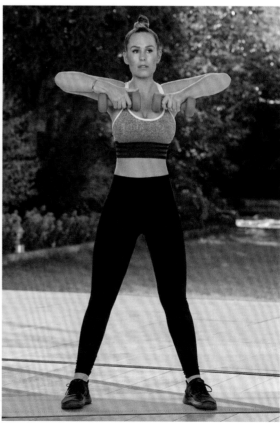

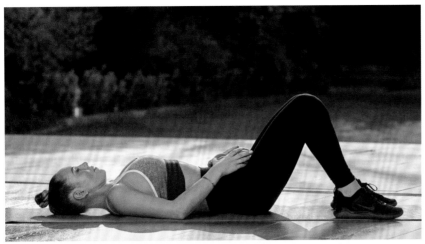

Weighted glute bridge

1 / Lie on your back with your knees bent and your feet flat on the floor.
Rest your dumb-bell between your hips while holding it with both hands.

2 / Raise your hips and squeeze your glutes as hard as you can. Hold the
position for at least 2 seconds.

3 / Lower back down to the starting position.

Notes:

Exercise notes

Goals

To help you get started perhaps set yourself three goals and set a date by which you want to achieve each one. Setting clear and realistic bench marks is a good way to inspire and help you get the body you want long term.

1: DATE SET: DATE ACHIEVED:

2: DATE SET: DATE ACHIEVED:

3: DATE SET: DATE ACHIEVED:

Four-week meal planner

I find that planning what I am going to eat, so I don't get caught out, really helps, especially when feeding a family. Why not use the recipes in chapter 2 to create a menu for the weeks ahead.

	Week 1	Week 2	Week 3	Week 4
MONDAY	breakfast	breakfast	breakfast	breakfast
	lunch	lunch	lunch	lunch
	dinner	dinner	dinner	dinner
TUESDAY	breakfast	breakfast	breakfast	breakfast
	lunch	lunch	lunch	lunch
	dinner	dinner	dinner	dinner
WEDNESDAY	breakfast	breakfast	breakfast	breakfast
	lunch	lunch	lunch	lunch
	dinner	dinner	dinner	dinner
THURSDAY	breakfast	breakfast	breakfast	breakfast
	lunch	lunch	lunch	lunch
	dinner	dinner	dinner	dinner
FRIDAY	breakfast	breakfast	breakfast	breakfast
	lunch	lunch	lunch	lunch
	dinner	dinner	dinner	dinner
SATURDAY	breakfast	breakfast	breakfast	breakfast
	lunch	lunch	lunch	lunch
	dinner	dinner	dinner	dinner
SUNDAY	breakfast	breakfast	breakfast	breakfast
	lunch	lunch	lunch	lunch
	dinner	dinner	dinner	dinner

Index

Credits:

Thanks:

Rio – Thank you for the early morning workouts; you are the best workout partner a girl could ask for. . . and you're not a bad husband either! You are my everything. Who knew a love like this existed? I am so lucky to have found you, we really did save each other. Thank you for being you, you complete me. xxx

Lorenz, Tate & Tia –The three lunatics, my poochies! You drive me absolutely crazy at times but I would not have it any other way. You have taught me so much and I will forever be grateful for having you in my life. You are my three beautiful babies and I will do everything I can to give you the happiest of lives. I love you forever and always. x

Michael Evans – You've been training me for years now and have seen me at my absolute worst. We've had lots of laughs and even a few tears! You are a true gentleman and have given me constant support in and out of the gym. Thank you for the 4 a.m. workouts and for always being on call when I need you – you never let me down. You have got me through some tough times and I always feel better after working out with you and for that I thank you.

Mel Deane – I've not known you long but thank you for training me the last few years, we do laugh and you push me to my absolute limits! Thank you for making me enjoy my training and take my fitness to the next level.

Ellis/Mikey/Sarrah –The dream glam team. Thanks for turning me into my alter ego Cindy for the amazing images in this book and giving me the confidence in front of the camera that I don't always feel inside. I love you all very much.

Dan Kennedy and Zoe McConnell – Two truly talented photographers. They got my vision and made me feel good on shoot days, something that I have struggled with for years.

Mokkingbird – My lovely agents Gemma and Nadia. Wow, where would I be without you guys? Thank you for not only being great agents but great friends too. You have helped me get through some tough times and been there to celebrate with me on the great times too. Thank you for pushing me (even when I don't want to be) and helping me to reach my full potential. I love you both very much. x

Penguin/Michael Joseph – Thank you to the entire team at Michael Joseph and Penguin for believing in me and giving me the chance to write the book that I have always wanted to write. It has helped me in more ways than you will ever know and I hope that it can help others too. Special thanks to Charlotte Hardman who has worked tirelessly with me and my team to make this book everything I dreamed of.

Jordan Paramour – I am no writer, but Jordan has helped me voice this book and she sat with me painstakingly for hours making sure that it was exactly right. We got there in the end!

MICHAEL JOSEPH

UK | USA | Canada | Ireland | Australia

India | New Zealand | South Africa

Michael Joseph is part of the Penguin Random House group of companies
whose addresses can be found at global.penguinrandomhouse.com

Penguin
Random House
UK

First published 2019

001

Set in Gill Sans, Better Times, Agenda and Bodoni
Colour repro by ALTA image
Printed and bound in Italy by Elcograf S.p.A.

A CIP catalogue record for this book is available from the British Library

ISBN: 978–0–241–38683–5

www.greenpenguin.co.uk

MIX
Paper from
responsible sources
FSC® C018179

Penguin Random House is committed to a
sustainable future for our business, our readers
and our planet. This book is made from Forest
Stewardship Council® certified paper.